ANDREW MARR

A short book about drawing

Quadrille
PUBLISHING

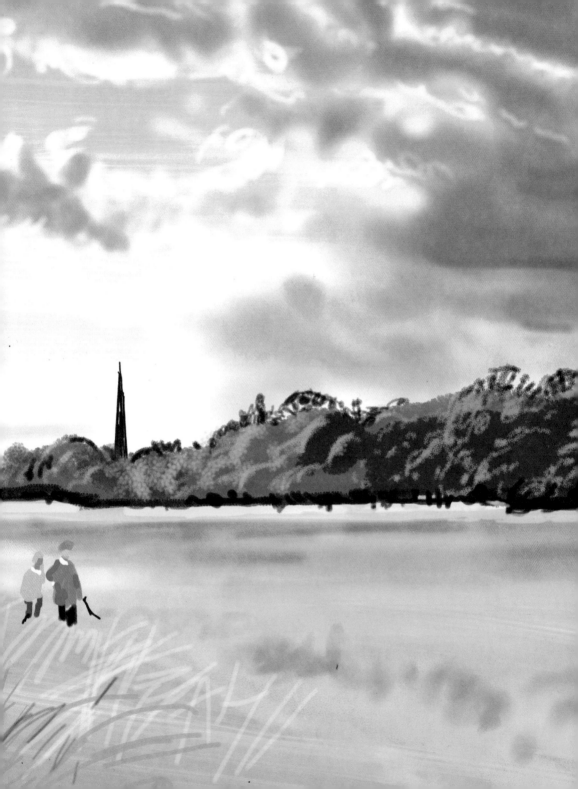

For Ed Victor

Publishing director: Jane O'Shea
Creative director: Helen Lewis
Project editor: Simon Davis
Designer: Lawrence Morton
Production director: Vincent Smith
Production controller: Sasha Taylor

First published in 2013 by
Quadrille Publishing Limited
Alhambra House,
27–31 Charing Cross Road,
London WC2H 0LS
www.quadrille.co.uk

978 184949 334 5

Printed in China

previous page
**RICHMOND PARK, WEST
LONDON**
One small corner of my local
paradise, but that's not the
point. This was drawn on my
iPad, and quite a lot of the
drawings that follow were
too. Apart from the fact that
one uses a metal stylus, with
a rubber tip, on a glass
surface, rather than graphite
on paper, it is completely
conventional drawing. The
speed and range of colour
are fantastic, but one loses
something subtle and
physical too.

CONTENTS

INTRODUCTION

This book was written during the winter of 2012. A few weeks after I had finished it, after over-exercising and a blinding headache, I suffered a stroke, which nearly killed me. When I started to recover in hospital, one of my early frustrations was that I found I wanted to draw. I really discovered for the first time, however, that drawing is a two-handed activity. You need your non-dominant hand to hold down the paper, sharpen pencils, and support the hand that is bringing the line. My left hand was, sadly, useless and my drawing was terrible.

I couldn't type either, but discovered effective voice-recognition software to deal with that problem.

LEARNING TO WALK
When I was learning to walk again, at Charing Cross Hospital, after my stroke, I felt very vulnerable and quite scared. Drawing my vulnerability helped: this was done quickly in chalk, after a photo. I am the object in red at the centre, wobbling.

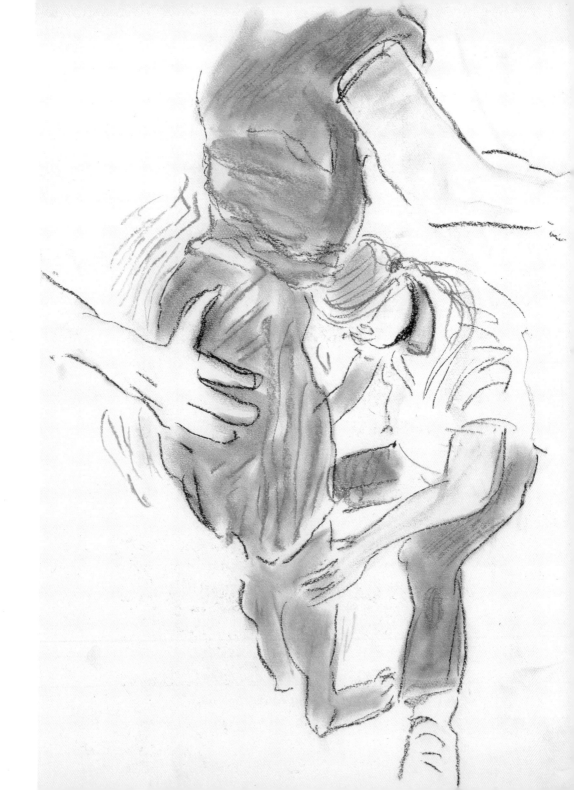

Technology jumps ahead by leaps and bounds these days, but there is so far no system of voice-recognition drawing. Yet my hospital had a very bright and determined "Art Therapist", who told me that many recovering stroke survivors found art essential to them, producing drawings and paintings of a high quality they had never thought they could make before they became ill. My only point is that the making of art seems to be a deeper urge or instinct than perhaps we assume in our ordinary lives. I certainly didn't feel that I was myself properly until I found myself drawing again, as it happens, on my iPad, which is simply easier than with a large piece of paper and tin of pencils.

I have called this "A Short Book About Drawing" because that's what it is. But it is also a book about being happy and the importance of doing and making, for a happy life. I've written books about all sorts of things, but I have never enjoyed one as much as this. When I look back at all those hours and days of drawing and painting, it is all sunny, even when it was really cold and raining and I was cursing myself for my lack of competence. All the illustrations are my own, for two reasons. First, they are free, while reproduction rights for the works of Manet, Goya, Picasso, Hockney and other artists I talk about here tend to be expensive. Second,

*it means that I can be as rude and frank as I like
about the failures as well as the successes in what
follows. There isn't a single drawing here I would
regard as a real work of art, but I think that most of
them will encourage people to try for themselves. For
above all, I hope this is a book which will persuade
you, whether you draw or not, to pick up a pencil
and face the horrifying blankness of a sheet of A4.
And then plunge ahead.*

Andrew Marr, *March 2013*

I'd like to thank the following people.
I am indebted to David Hockney, Antony Gormley, the staff at
the Courtauld Institute and the Royal College of Art, and to
many friends with whom I have been able to discuss drawing
over the years. I can't draw very well at the moment, being
effectively one-handed, but I'd certainly like to thank my wife,
Jackie Ashley, without whom I would not have come through the
experience of the stroke at all. She and my three children, Harry,
Isabel and Emily, kept me going through some dark times, when
I felt frustrated and more miserable than I let on. Also, the staff,
from therapists and doctors to nurses and cleaners, who looked
after me so brilliantly at the Charing Cross Hospital in
Hammersmith, West London, and then Queen Mary's Hospital,
Roehampton, and Tom Balchin, my personal and ferocious rehab
coach. Next, my assistant, Mary Greenham, herself the daughter
of distinguished artists, who has organised and made some sense
of my chaotic life. And, as the dedication shows, my kind yet
ruthless agent Ed Victor. This book was his idea. The man is a
legend, and not only in his own lunchtime. Last, but not least, I
have to thank all the wonderful people at Quadrille, silk purse-
makers who have made the making of this book a joy. That's a lot
of thanks; but I'm a lucky man.

1 FREE SPACE

Like millions of others, I draw. Scribble, scribble, scribble. Faces, trees, buildings, streets. Why? It's an impulse. I can't help myself. And doing it makes me happy. And as I get older I get more interested in impulses, and in what makes us happier.

Up to now, drawing has been my private space and has been since childhood. One way or another, I draw most days, even if it's a doodle on the edge of a newspaper; most weeks there are pictures which have taken an hour or more. They used to be drawn in diaries, or whatever blank paper was handiest. Now they are often on my iPad. In a good year, there will be a week or two when I can actually get out into the open air with a grimy bag full of oil paints and a canvas, or piece of wood, and make a bigger picture.

RECORDING CATTLE NOISES, THE TRANSVAAL Most of the drawings here were done in thick, black-backed notebooks I use for my daily diary. This is a fairly typical page, showing the cameraman and a sound recordist at work with me in South Africa, made standing up and done at speed.

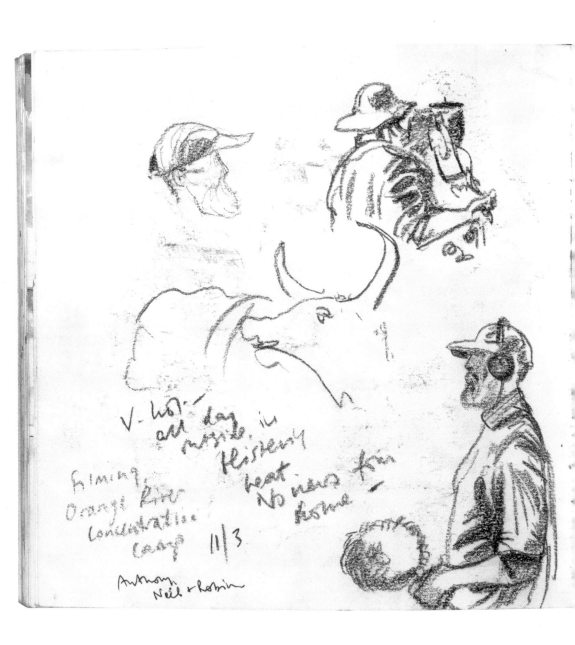

V. hot day
all day, in
mobile, in
blistering
heat

filming
Orange River
concentration
camp 11/3

No news from
home

Anthony
Neil + Robin

Then, I am at my happiest. There will be problems ahead. A gust of wind overturns the sticky, paint-loaded canvas and carries it jam-side down, onto a patch of mud. Flies attach themselves to my clouds, expiring in Flake White. Rain spatters. I huddle under a tree, but the spattering gets heavier. More important, there will be the personal failures to come. I'll spend too much time struggling with some detail, and somehow it will end up a dibby-dabby incoherence. Or slowly, over the course of a few hours, it will become all too apparent that my original drawing, the structure of the picture, is simply not strong enough. It must be thrown away.[†] This is a real failure. Failure in drawing is a failure in skill; but more often a failure of courage.

Meanwhile, however, time's arrow seems to have been frozen in mid-air. The boil and bubble of agendas, to-do lists, deadlines, unanswered emails, meetings to be arranged, shopping lists – the press of the hours and minutes we all feel – vanishes. The Things That Must Be Done simply wander off for a while and stand grunting quietly under a tree while I look, and draw, and mix, and brush, and look and mix, and look...

I've lost count of the number of times that my arms seem to have turned hot red with sunburn, and I simply hadn't noticed. Once the light has changed too much, or the picture seems to have finished itself, I'll wipe brushes, screw the tops back onto the tubes, try to clean the palate, and carry everything home again. Mostly I will be wondering, yet again, why any combination of colours, smeared across

THREE QUICK PORTRAIT STUDIES
And here are three other examples from the same notebook – the writing is on the facing page. These show my cameraman, Neil Harvey, my fat and dishevelled cat Charlie, and the Rolling Stones musician Ronnie Wood, who was drawing me at the same time. The picture of the cat is the least successful: partly because he is a cloud of hair in constant movement, and clouds (and hair) are difficult.

[†] Pleasingly, this happens to real, great painters too. In a new biography of Cezanne, Renoir is quoted on the great father of modern painting that after working on his landscape, he sometimes came "away disappointed, returning without his canvas, which he'd leave on a rock or on the grass, at the mercy of the wind or the rain or the sun, swallowed by the earth..." (Alex Danchev, *Cezanne, A Life* Profile Books, 2012, page 97)

FREE SPACE

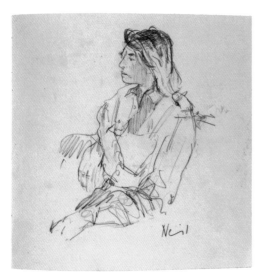

Neil

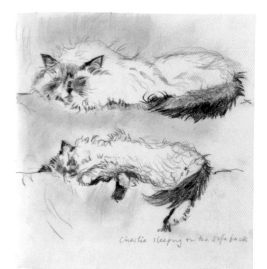

Charlie sleeping on the sofa back

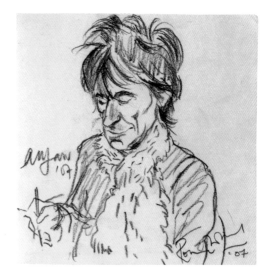

anjan '07

Ron Wood '07

hands, eventually becomes a particular shade of sludge green? Sweating and my eyes itchy with too much strained looking, I will walk back, sometimes with a sketchpad and bag of pencils, sometimes with an oily canvas sack and a sticky board. Any good? Have I learned something? Remembering Samuel Beckett, have I failed better?

Oddly, even if the answer turns out to be no – and the answer is only clear an hour later, when I've cleaned up and gone back to look at the picture – I am completely happy. This is a short book about drawing but really, it is a book about happiness. Whatever I am doing when I am drawing, it has some relationship to whatever people are doing when they make music, pray, dance, write. How does it relate to the "art world" though? Does it have a point, or is the point that it doesn't? And if so, what am I doing? If you draw too, what, really, are you doing?

Here, at the beginning, I have deliberately mixed up two things, drawing and painting, which most people who write about art will say are distinct, and in some ways very different. They are different, and we will come on to that later, but for me they arrived pretty much together, lines and space between lines, crayoned or felt-tipped, filled in or dotted. I can tell instantly if a drawing has worked or not; the painting takes a little longer to sort itself out; but they seem to me no more different than the difference between, say, piano music and choral music.

In both cases, I have been doing something that feels somehow stripped-down and essential; and for

no other reason than the doing of it. Charity do's apart, my pictures aren't for sale (or probably saleable) and I don't have any wall space left to hang them. I'm not following a school, or a teacher. I haven't had drawing lessons, at least since becoming a teenager, and I don't go to classes. The pictures record tiny advances, probably only visible to me. With the demands of work, family and friends, I have far less time to draw and paint than I'd need if I were to really move forward. I want to. Yet like most people who draw regularly I have a distinctive hand. My tics, or quirks, of drawing have barely changed in 30 years. Most of my old pictures have been discarded or otherwise disappeared. But quite a lot are stacked up in the corner of a garage, sometimes framed, sometimes not. Or they're piled on top of dusty cupboards, a silent record of hard-working happiness.

Drawing is a bit like fishing. When he was younger my Dad was a keen fisherman, and when I was a boy he would take me out on a river on the Scottish east coast, with snow whirling in the sky, or we would walk up to a Highland loch, a long hike in the summer sun, and push a rowing boat out across the peaty black water. He helped me enough for me to catch a fine, big silver salmon once – almost too heavy to hold up by its tail – and some glossy, pink-speckled brown trout.

At other times, we would hire a little boat with an outboard and chug into a sea-loch, dangling hooks and feathers and hoick in bag-loads of mackerel, to be rolled in oatmeal and eaten with bacon for

breakfast. But if there was a shoal nearby this was almost too easy. There were days with white horses on the Prussian Blue water and nothing biting. There were days on a flat, oily-calm loch when the only things biting were midges; or when a heart-racing tug on the rod was followed, a minute later, by a ping, and the sharp disappointment of a broken line. Yet every time, laden with fishing bags, pencil boxes full of flies, a net and a gaff we had set out full of hope. This would be the day for a big one, something special to carry home and show off.

Well clearly, drawing and fishing are different activities. You can't eat pictures. (Though I have ingested quite a lot of oil paint and charcoal over the years, absent-mindedly licking a thumb or a brush, I don't recommend the Van Gogh diet plan.) But, just as you never know what you're going to catch, you never know what you are going to draw or paint. You set out with hope. This time, perhaps, it might be a spectacular breakthrough. Mostly, it'll turn out as a modest disappointment. As with fishing, the reasons for failure can be mysterious. Sometimes they are external – the wrong light, a too-strong wind, not enough time. Mostly, in painting, it is a failure of nerve – the nerve to leave alone, or to trust your eyes – and above all, the nerve to be absolutely honest, absolutely serious.

Nerve may seem an odd word to use. If you have ever watched somebody painting, or drawing, you may be struck by the apparent peacefulness of the scene. Even when painters portray themselves or

THE JOLLY BOATMAN
A different kind of fishing, done while filming on the River Nile. This boatman was self-confident but not very dexterous and kept failing to take us to where the camera needed to be. The light was failing and everybody, except the boatman, was getting very stressed. I had to keep calm and did so by drawing this engaging and cheerful incompetent.

FREE SPACE

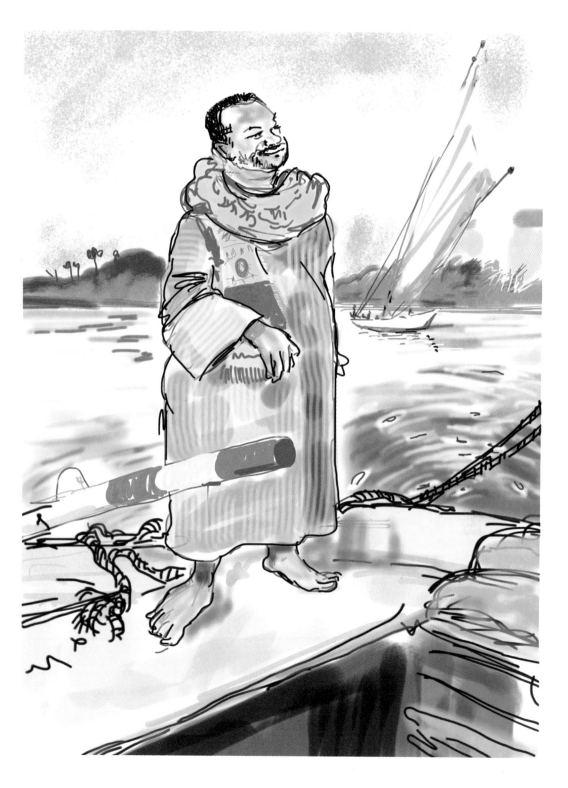

their friends painting, it often looks all loll and murmur. Renoir's friend Frédéric Bazille (who might have been very famous had he not been killed at 28 in the Franco-Prussian war) calmly dabs at a canvas, feet crossed. Manet shows Monet on a houseboat, easel up, under an awning, floating on blue waters, apparently blissfully at ease. John Singer Sargent shows brush-men at work – including Monet – at the edge of woods or rivers, an adoring female in a big hat dozing nearby. Picasso's drawings of himself painting in old age are raw, angry, self-mocking and full of frustration. But he is in that, as so much, unusual. Observe someone with an easel up at a roadside, or with a sketchbook on holiday, and you may think, what a gentle occupation.

Painters' self-portraits are more revealing. Surprisingly often, they are glaring. The mouths are downturned, the shoulders hunched, the eyes almost popping. From Rembrandt to Freud and of course Picasso himself, there are few friendly, cheerful gazes. The reason is obvious. Drawing and painting are hard work. They require full concentration – frowns, grimaces. I am lucky enough to be friendly with David Hockney and he made a watercolour of me. Normally he is the most generously loquacious of men, someone who enjoys talking, above all about the making of pictures. But when he's painting, his mouth is pursed, his shoulders are tense and his eyes bore into you. He isn't in the mood for idle talk. Concert pianists rarely chatter, either. When I draw myself (the only life subject with any patience) the

results are often rather forbidding. I tried to draw myself smiling once but had to hold a grin. The result was (see cover) chipmunkish.

When most people are drawing or painting, under the quiet surface, there is a mental drama going on. Drawing or painting is a test of spirit, self-belief and of determination; every stroke, like every cast of the fisherman's fly, has a meaning. The painter, like the fisherman, can be beaten, and limp home. But they will both be back. This doesn't mean drawing is painful. Far from it. Antony Gormley is Britain's best-known sculptor, one of the leading sculptors in the world, and he draws every day. In his drawing studio, he says that "this is my most important place. It's a place of freedom and experiment and play." All the rest of life, he adds, is about deadlines and meetings and goals, but "drawing is for me the zone of freedom, fertile ground, out of which all my work comes."

Those words – freedom, experiment, play, fertile ground – seem to me the essential other half of recognising that drawing is proper, hard work, demanding full attention.

By the time I was taken fishing, I was already painting. How did it begin? The way it does with most people, with crayons at school. I went to Dundee High School, aged five. It was an excellent school but in classes of forty children, I was a bad pupil. I read, early and easily, but got very quickly bored listening. Even today I simply cannot sit still and listen to someone talking at me, however clever. At "the High", I shuffled my bottom towards the

back row of desks, where I could not be clearly seen, and drew pictures. I drew on my jotters. I drew in the margins of schoolbooks. I drew on tiny scraps of paper. I drew on the wooden desk. I got into trouble at home for drawing on white-painted walls – low down, behind chairs, where I thought nobody would notice. When asked what I wanted for a present, I would apparently say, "plain paper and pencils".

What did I draw? At that stage, things out of my head. I suspect most children start by drawing from their imaginations rather than by looking. So most of it would have been the banal imaginings of a small boy – funny faces, Scottish soldiers fighting English soldiers, British soldiers fighting German soldiers, spacemen, creepy witches, fantasy cars, special big lorries. They've all gone. One drawing my parents did keep shows my father and does have an interesting sense of a child's perspective: the feet and legs are huge, and the rest of him recedes upwards in space. I bet many children draw adults just like that.

The next stage that I remember was being given a small Dolphin Art Book about Van Gogh. I was probably about eight or nine. On went a very bright light bulb. It must have been similar to the first time a musically attuned child hears Bach. The complete excitement about the colours, textures and wildness of Van Gogh's pictures remains uncontaminated now, more than 40 years later. My parents bought me other books – collections of pictures from art galleries, books on Monet and Manet, Seurat and Renoir. I started to save up and buy more myself.

FREE SPACE

More generally, and more commonly, I was surrounded by drawing. Before the ubiquity of TV and computer screens, there was just more of it around. Picture books were essential to entice young minds. We learned to read with drawings, from rubbery Janet and John to the dark brilliance of Babar and the manic energy of Dr. Seuss. (It's interesting that illustration is such a successful cross-cultural bridge; I only bothered to struggle with French because of the Asterix drawings by Albert Uderzo.) For history, the Ladybird books had bright, well-made pictures on every right-hand page. For fun, the comics of Dundee's D.C. Thomson came every week – Desperate Dan, Lord Snooty – and that Scottish institution *The Sunday Post* had two full-page strips, The Broons and Oor Wullie. Then there were the war-stories of the Commando picture books and the War Picture Library. People may deprecate the politics or militarism of all this – the writer Tom Nairn once said Scotland would only be free when the last Presbyterian minister was strangled with the last copy of *The Sunday Post* – but the drawings were skilled and quite easy to imitate.

Nor was it all for children. Old-fashioned houses had illustrated encyclopaedias in the bookcases, Bibles with coloured plates and perhaps collections of old *Punch* anthologies. I spent days lingering over the drawings of Leech, Phil May, Armour, Bateman, Fougasse, while barely noting the jokes.

Now I believe that there was a golden age of British drawing from around 1870 through to the

ON THE ROAD, CHINA
Making use of unpromising circumstances. I spent a lot of time in cars, in this case on a long journey in China, and coped with the jolting while drawing our Chinese translator, Lillian. Without this simple contrast of three colours, this would be a very dull picture indeed.

FREE SPACE

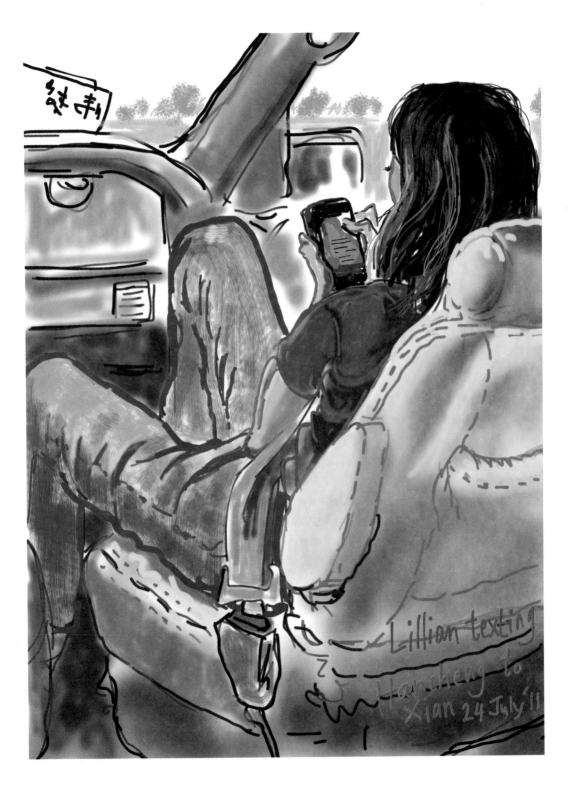

1930s. Mass education had created a market for papers, magazines, poster adverts and cheap books and for a while photography was too grainy, expensive and slow to quite keep up. So the fast-on-the-draw merchants stepped in. A distant relative of mine made a kind of living drawing for cowboy stories and sketching the new fashions for department stores each autumn. Another, who was killed in his Spitfire over Norway, made such skilled drawings of RAF aircraft the War Ministry impounded them. I have and treasure his RAF "wings" and his copy of *Seven Pillars of Wisdom*.

As a child of the 1960s, however, this golden age of drawing was already over. Photo-journalism was at the height of its fashion. Kids began to prefer the moving pictures of telly to comics. The newspapers kept cartoonists for the editorial pages, but they were there for their wit and political insight as much as the drawing. When the first editions of the colourful new *Sunday Times Magazine* arrived, they would sometimes have drawn pictures or articles about artists to stare at. I remember the English "Brotherhood of Ruralists", a largely forgotten movement now, and pictures by Peter Blake.

It is important, though, to bear in mind that drawing – and painting – were never identical to "fine art". For a long time the boundary was fluid. William Nicholson, one of the finest English twentieth-century painters, made his name first with commercial posters and book illustrations. And Henri de Toulouse-Lautrec, perhaps the top

draughtsman of the greatest age of French art, is as famous for his posters for nightclubs and singers as for his paintings.

Later on, I want to look at what has happened to drawing now, in today's art world. But drawing also lives, and always has lived, outside the galleries and the catalogues. It's why many of us who draw are uneasy about the word artist. "So, you're an *artist*, are you?" That is what older relatives and friends say to kids who are beginning to delight in making pictures with pencils, and it can be patronising. An artist, we know, is someone with a High Calling, even aspirations to Genius, a creature cut from a finer cloth. *Call yourself an artist?* It's a little like challenging anyone who studies first-grade piano to compare themselves to Daniel Barenboim.

No. I draw. He draws. She draws. We draw. That's all the conjugation needed. Since starting this book, I have been a little more aware of other people drawing, and they are everywhere. A Japanese woman furtively sketching other travellers in the London Underground; a young man painting by a beach; students copying at big art exhibitions; busker-caricaturists; a pub offering life classes upstairs with beer. Once you start to look you realise how many we are.

Still, I was lucky and unusual in having parents who were interested in "proper art" and, when they had some spare money, might buy a picture by a Scottish painter to put on the wall. I would be taken every year to the annual exhibition of the

Royal Scottish Academy. It was something of a family ritual. We'd go round, room by room, giving verdicts on who was on form, who had become repetitive, and discussing the most exciting new names.

Also, painting was something done by normal people all around us. The most popular artist in Dundee was the meticulous landscape painter James McIntosh Patrick, whose pictures of Angus and Perthshire capture the shapes and colours of east coast Scotland like nothing else, and now sell for a small fortune. I would cycle round the country roads and sometimes see "old Mackie P", as he was known, sitting in the open back of his estate car, easel out, working away. My parents were friendly with another famous Dundee painter, the exotically named Alberto Morrocco. My maternal grandfather had always wanted to be a cartoonist but had been shunted instead into accountancy, and he had lots of drawings to look at, often from his time in the Eighth Army in Italy. A more distant relative was one of the great Scottish Colourists foursome, an alcohol-stricken genius called Leslie Hunter. So drawing was never odd. Loads of people did it. Only now do I realise how lucky I was.

By the time I went to boarding school, at nine, painting was a private place where I could escape the dreary business of Latin conjugation, horrible cricket practice or lectures from retired admirals and alarming Kirk ministers. I'd moved on from school paints – those plastic canisters of primary-coloured powders, to be mixed with water – and crayons, to buying cheap

SUBURBAN GARDENS, EAST SHEEN
This is a pretty banal view, to be honest, but I wanted to capture the intensity of autumn light. One of the most exciting things is the extremities of green and red and pink which arrive with winter and the slanted angle of the sun.

FREE SPACE

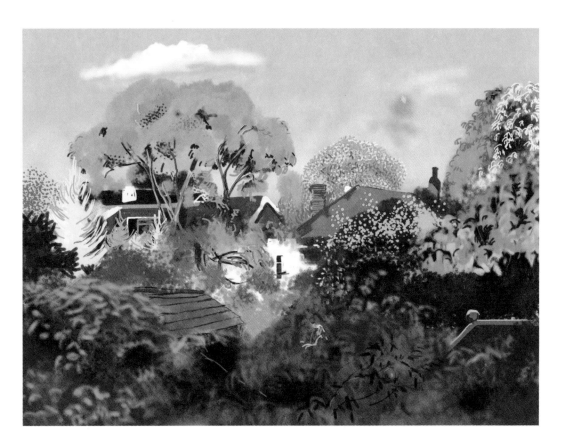

sets of gouache. Gouache is wonderfully flexible, because you can water it down until it's almost like watercolour, but also slap it on with a knife, or in thick gobbets, like oil. It cracks, unfortunately, but it is the best paint (I think) to start with. By the time I was at my main school, Loretto, I was sometimes able to go off and paint in oils. I remember one snowy day, in the nearby village of Inveresk, perished with cold at the side of a wood and stream, but absolutely sure I was Claude Monet reincarnated.

I had managed to stop drawing on walls, but my bold housemaster once let me paint a huge mural in a corridor. It was of knights and used lots of bright pink and blue and, mercifully, disappeared long ago. Our eccentric, determined and rather brilliant art teacher – Artie Baxter – suggested I might think of Edinburgh College of Art, perhaps the best in Britain at the time. I went to university instead. It may have been a mistake.

Painting and drawing, however, stayed with me. I did cartoons for university newspapers and left-wing magazines. I sketched friends and doodled in notebooks. Once I had started work as a newspaper journalist, I would occasionally go out and paint, though time was always short. As I got older, the urge to draw became stronger, not weaker. But also, as I get older, I think about it more. It is no longer just a blissful pool of water to swim in, or "an escape". I want to try to understand more clearly what it is I have spent so much time doing.

LIFE IN SCOTLAND IN THE 1960S
These are early Marrs. My father smoked an aromatic pipe, though he gave up long ago. I am the one with the gun and the psychotic stare.

ANDREW (5)

2 DRAWING AND HAPPINESS

Let's return to that apparent tension between drawing as hard concentrated work, and drawing as a zone of freedom or play. Mihaly Csíkszentmihályi is the world's leading answer to the proposition that people with unpronounceable names don't get very far. On the other hand, the core idea of this rotund Hungarian happiness-guru, who lives in the US, has a satisfactorily short name. It's "flow", and it resolves any seeming contradiction.

Flow is the proposition that we are happiest when concentrating as much as possible on something that's both quite hard and for which we have an aptitude. It is "being completely involved in an activity for its own sake. The ego falls away. Time flies. Every action, movement, and thought follows

BEAUTIFUL TREE, DEVON
A small tree in Devon, down an obscure muddy track. I find it deeply pleasing, I don't know why, and have drawn it repeatedly. When I'm walking by myself, I like to carry a tiny notebook to make jottings. It turns a walk into an adventure.

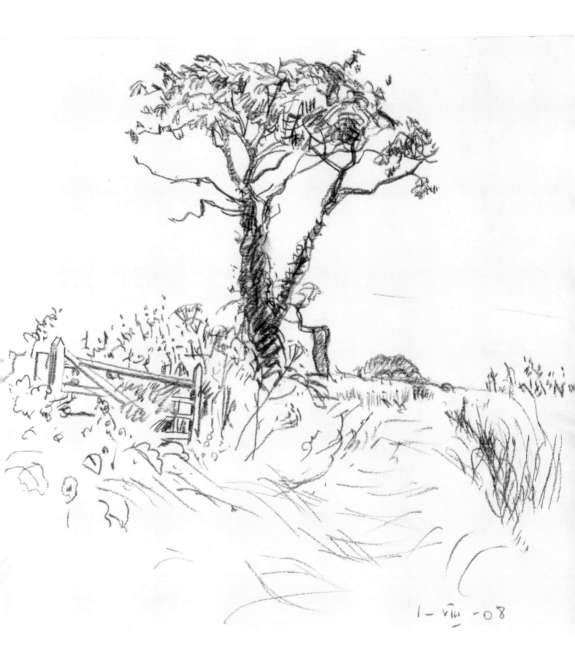

1 – viii – 08

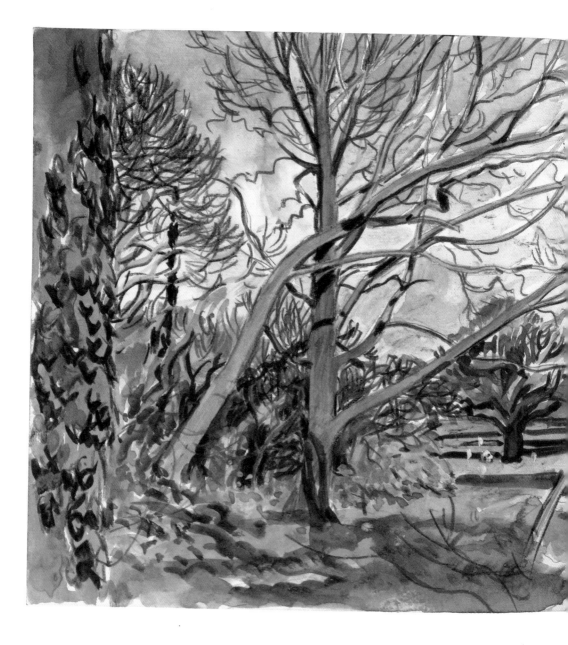

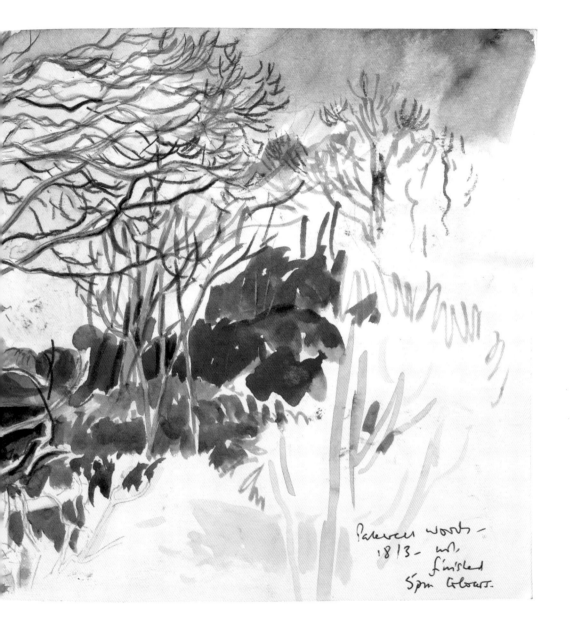

Palewell woods –
1813 – not
finished
5 pm Colours.

inevitably from the previous one…your whole being is involved, and you're using your skills to the utmost."

So this isn't "chilling". It isn't relaxing, or taking "time out" (and what a bizarre thought that is, given how little time we get). It sounds a lot like meditation, a method of self-mastery, developed over many years. It's not flopping about in a water tank, or smoking a joint. Mihaly – let's call him Mihaly, shall we? – is likelier to compare flow to making music. It is certainly something which requires absorbed activity and skill.

Of the lucky proportion of adult people who experience flow, most don't get it in their working lives. I suspect the working categories we tend to admire most – scientists, brain surgeons, people like that – are in the small group who love what they are paid to do so much that they really do experience the ego falling away as the "whole being is involved". Indeed, one powerful notion of the good life is just that – work which absorbs you, mind and body, at the peak of your concentration and skill.

This needn't be "elite" work. Think of old-school farmers, who had a deep knowledge of their land, who were naturally sensitive to changes in wind and temperature, who observed closely budding plants and shedding leaves, and walked the same woods and fields long enough to see trees grow and die, or soil thicken and strengthen. That sounds like flow. Or think of true mechanics, sure of their tools, their knowledge and their memory of engines.

previous pages
LOCAL WOODS, EAST SHEEN, IN THE COLD
Flow, or the result of flow, of late evening light. I was concentrating hard, but couldn't finish because my fingers were simply too cold to keep working.

The trouble is, in a developed late-capitalist economy, relatively few people have the overview and personal knowledge for such complete involvement. We are digital cogs, office drones.

Another writer I've found helpful in thinking about this is Matthew Crawford, an American political philosopher who now works in a motorcycle repair shop. He recently wrote a passionate, revolutionary book which he called *The Case for Working with Your Hands; or Why Office Work is Bad for Us and Fixing Things Feels Good.*"[†]
The title says it all. Crawford argues that by distancing ourselves in our digital economy from the real world of objects and making, we are actually limiting our intelligence.

For our intelligence is embodied. As I have rediscovered for myself since my stroke, our hands and muscles are part of our consciousness. We are not brains bobbing in some neutral tank, and if we leave the world of doing to others, we make ourselves stupider. The professional doer is a lover of excellence and the specific. Crawford points out that when trying to repair motorcycles, he "experiences failure on a daily basis". But these confrontations with hard reality teach humility and persistence. They help us achieve greater self-reliance.

All this seems to me to relate quite closely back to the case for drawing. It is a source of happiness and even inner strength not because it is easy but because it is hard.

But what, really, is it?

[†] Matthew Crawford, *The Case for Working With Your Hands*, Viking, 2009, published in the US as *Shop Class as Soulcraft*

3 LINES

It is sometimes said that there are no lines in nature. Scientifically, that is obviously true. We are blobby, fleshy, bumbling-around three-dimensional creatures glued inside a blobby, colourful three-dimensional world – or four dimensional, if you count time as a dimension.[†] Nothing in nature is two-dimensional. Nothing. Everything we see has mass. It's all rounded, showered with light. This means, of course, that everything is mysterious. It is partly out of sight. It has another side. We cannot see it all at once, or know it from the other side.

John Ruskin, the great Victorian art critic, who was a fine artist himself, said in his book on drawing that it all depended on representing roundness. "For Nature is all made up of roundnesses… Boughs are

CENTRAL PARK, NEW YORK
Lines representing mass and distance. My great vice as a drawer is fiddliness. Here, for once, I managed to keep it simple.

[†]Or up to eleven if you follow modern physics; but four is enough for daily life, including drawing.

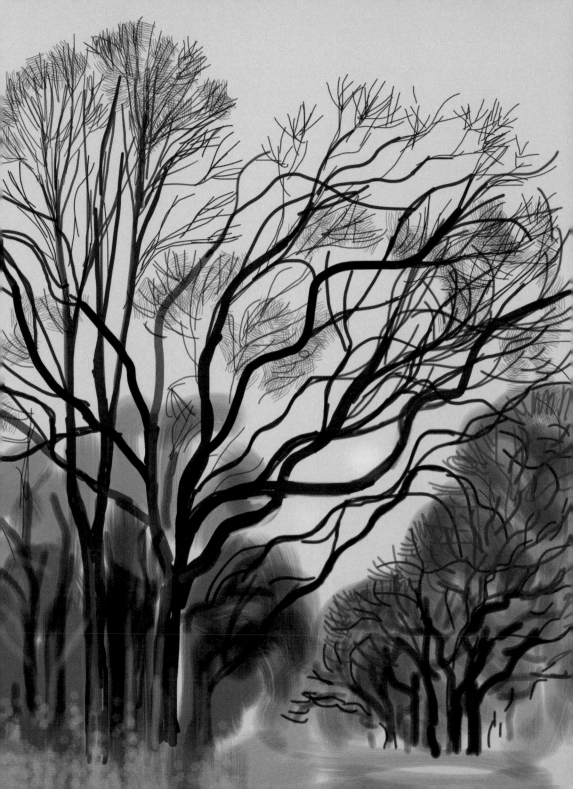

rounded, leaves are rounded, stones are rounded, clouds are rounded, cheeks are rounded, and curls are rounded: there is no more flatness in the natural world than there is vacancy."

But if there are no lines in nature, there are certainly lines when the human eye looks out at it. The lines are where the curve of three-dimensional blobbiness disappears from our sight, leaving silhouettes, hard-seeming edges. The experience of this is so intrinsic to being human that it's impossible to imagine seeing without edges – the edges of tree branches, hills, other faces, coffee cups. Some painters have dreamed of showing not the edges, but the three-dimensionality, the roundness and "thinginess" of things, and to bring alive the spaces between them.

This was the project of Cubism. But though it produced some very fine pictures, it was in the end a mimicry, depending on a flattish surface covered with lines. Other drawers use powder on wet paper, or rags soaked in ink, or similar devices which blur lines. Yet we still see lines. We can't help it.

Film-makers are just as stuck with lines as someone armed only with a pencil. The lines in films may move, sometimes very fast, but unless the film is simply a wash of colour – like Derek Jarman's *Blue* – the lines are always there. Even if the image is a vague swirl of light and colour, it is bounded by the lines of the screen, of course, beyond which the camera cannot reach.

This is because seeing lines and being a human

PLASTIC BAGS
Just lines - very thick lines and very thin lines. The most banal objects have their own beauty too.

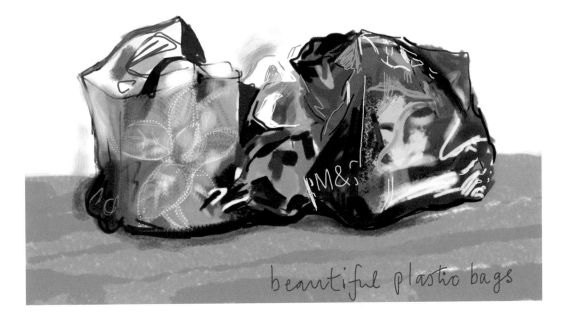

beautiful plastic bags

being are – except for the blind – inextricably linked. Lines are the necessary shorthand, the abstraction, used by the brain to pass on essential information about the slippery world all around us. Whenever we see lines, we are using, as it were, a process of chemical algorithms to sort out what's what.

Lines are something-simple-standing-for-something-else, built up in stages to create a useable idea of reality. Every second that our eyes are open we are collecting bundles of lines which form themselves into the reality of a coffee cup, a child's face, sunlight falling through trees, a Citroen; and we do this so seamlessly we never think about the near-instantaneous translation that's going on.

Well, almost never. Any decent illusion, from a mirage to Necker cubes, or Escher's famous impossible staircases, or perhaps simply a cleverly placed mirror in a restaurant, will make us double take. The sensation of being upended is a useful reminder to concentrate harder, one we seem to value and even enjoy. Some drawings or paintings can have the same effect. They can act to make us think about visual translation. They remind us that lines are an abstraction, and can mislead us for instance in surrealist pictures such as Magritte's or in the eye-swimming optical dances of Op Art.

And here is the magic. Good drawing (or painting), that abstraction-of-the-abstraction, also changes the rest of the world. It uses those lines to make us think harder. Drawing can make us see the familiar as we have never seen it before. It can make

DELIVERY BOY, SLEEPING
Lines representing a rickshaw boy in Shanghai. People have an uncanny sense of when they are being drawn, I've found. This is unfinished because he woke up, spotted me, and briskly cycled off. Did he think I was going to report him for sleeping on the job?

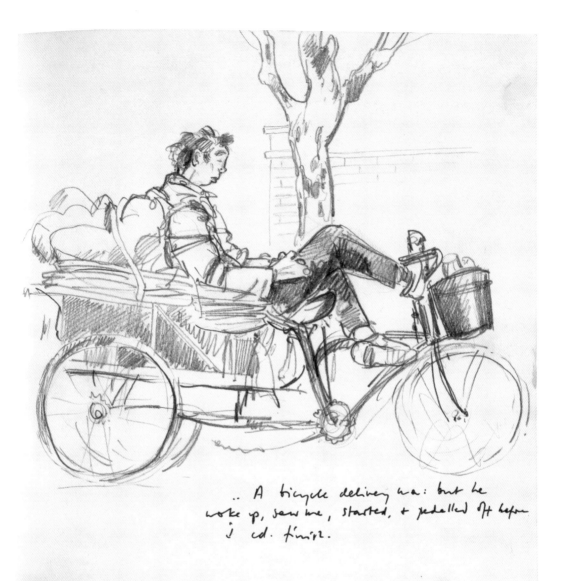

.. A bicycle delivery wa: but he woke up, saw me, started, + pedalled off before I cd. finish.

us *think about* seeing, as well as simply seeing. There were lily ponds before Monet but they didn't look like lily ponds look, now that he's done his work. Like Isaac Newton, the painter has given the world information we cannot now unlearn.

4 DRAWING AND PAINTING

So far I have blurred the question of what a drawing is, as distinct from a painting. However, the answer is blurred too. Just saying that painting "uses colour" won't work. The meticulous pencil drawings of great English artists up to and including Turner are often hand-coloured, so they become more like watercolour pictures. They are paintings *and* they are drawings. Great French drawers such as Watteau used two colours of chalk – red and black, sometimes lightened with a little white – to give the brilliant illusion of colour, a flushed cheek or a bright gown. Degas might draw with charcoal and pencil and then suddenly introduce a flash of chalked colour. Does that make his drawing a painting? Then there were painters who used a tube

STRAPHANGERS, EAST LONDON
There's a wonderful organisation called the Campaign for Drawing and they have an annual event, aimed at encouraging everyone to come along and have a go. It's infectious. This was done on a busy tube on the way there, looking at the hands of the swaying travellers.

On my way to the Festival of Drawing, 14ᵉ Oct

of oil paint like a pencil, making swift, brilliant lines. In certain moods, Dufy, Matisse and Vlaminck are examples. Are they drawing or painting?

Some galleries solve the question by speaking not of drawings, but of "works on paper" – though that, in turn, can also mean prints. Certainly, for most of art history, paper has been crucial to drawing, and not just in the obvious way of providing an easy-to-use, portable surface. One place I went to, to find out more, was where every winter lots of people go to skate – Somerset House, the grand square off London's Strand. Once it was the headquarters of many government offices, including the Inland Revenue and the Navy Board; now it hosts the Courtauld Gallery and its parent, the Courtauld Institute of Art.

The Courtauld was created in the 1930s to train future generations of art specialists, who would learn discrimination by studying paintings and drawings. These were gifted by a clutch of generous and forward-thinking benefactors. The gallery is small and reached by a spiral of stone stairs. It includes fabulous Rubens sketches, a treasure-trove of Impressionists and post-Impressionists, and much else. The drawings, hidden away next door because they are so fragile, number around 7,000 and run from the great names of the Renaissance to Picasso and Matisse. If there is anywhere you can go to talk to people who've thought deeply about what is a drawing, and what is a painting, it's the Courtauld.

So I went, one damp, dank November evening. I found myself, heart thumping, sitting at a desk

THE SLUM TAXI, DHAKA, BANGLADESH
Not a painting, really, but a coloured drawing. The colour is essential, demonstrating the eerie chemical fog and pollution these cheery and admirable people have to cope with everyday.

DRAWING AND PAINTING

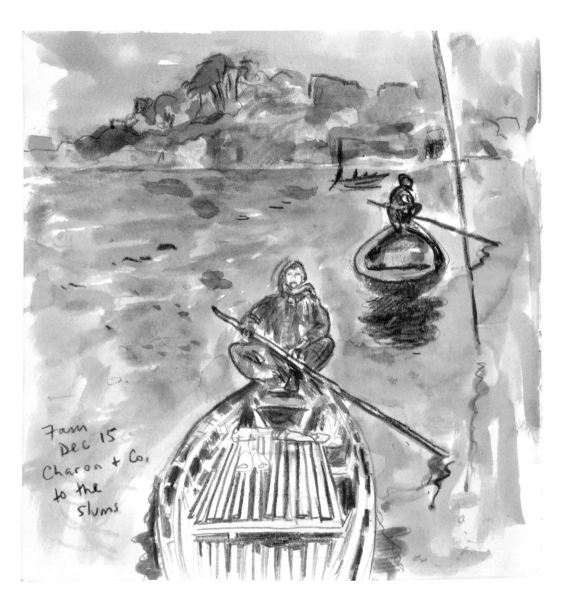

7am
Dec 15
Charon + Co.
to the
slums

with Stephanie Buck, the drawings curator, and a dozen small sheets of paper. On them there were marks and rubbings and corrections, in ink, and crayon and pastel and paint by – well, by Dürer, Michelangelo, Rembrandt, Rubens, Watteau, Cezanne, and others. The best of the best.

For a recent, big show of the Courtauld drawings, Stephanie had quoted two thinkers on art about what's a drawing, and what's not. The German sculptor and symbolist Max Klinger argued that compared to painting, drawing had a "freer relationship to the representable world" – it could allow the imagination to supply "the missing element of colour."[†] As I've already suggested, I think there is more to this than colour/no colour. But the sense that drawing is more open, and requires the watcher to fill in more, is spot on. Stephanie Buck then calls in evidence David Rosand, the American scholar of drawing, who emphasises the open and incomplete nature of drawing, and its ambivalence: "More insistently than the brush stroke in painting, the drawn mark resists surrender to…pictorial illusion."

Or, to put it bluntly, drawing makes you – the watcher – work harder. You don't get the mind-soothing, mimetic sweeps of blue or yellow standing for sky or cornfield. All you get is lines and marks, made by twitching fingers, whose evidence is left like clues on the paper. Your brain, the watcher's brain, has to supply the rest. Many painters seem to hope that the watcher forgets that the thing they are

RAGPICKERS, DHAKA
The main rubbish tip in Bangladesh's capital. Every scrap of plastic, every tiny piece of rubber or metal is salvaged for resale by women and children who are at the bottom of the social pile. Clouds of birds and flies and an unimaginable stink, which hangs on your clothes for hours afterwards, made this a difficult drawing to do. But look at the sense of colour they show in their clothes!

[†] *Master Drawings from the Courtauld Gallery*, ed. Colin B. Bailey and Stephanie Buck, the Courtauld Gallery and the Frick Collection, 2012, page 16. If you are at all interested in old master drawings, this book is a must.

DRAWING AND PAINTING

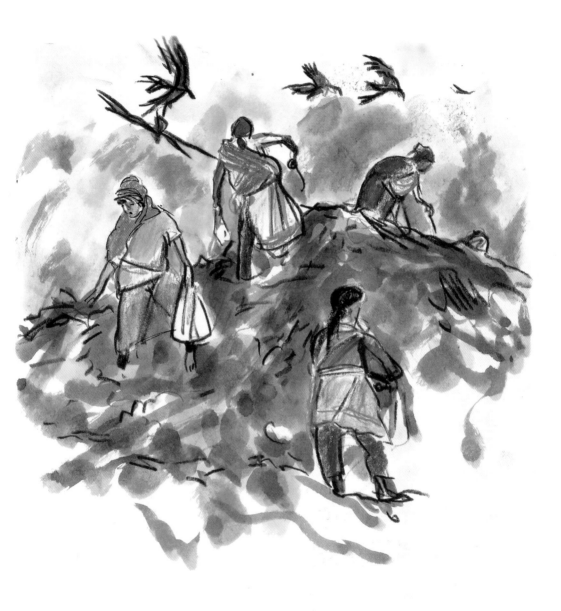

looking at is an illusion, a manual fiction. A Millais picture with water rushing over rocks, or a thick outcrop of grass, aspires to make you forget at least for a second that he painted it.

In drawing, this is never so. One hand held a sliver of chalk, or a piece of graphite, and by twisting and pulling, made some lines. Now it's your job to translate the lines, to answer the riddle.

This is unpredictably exhilarating. It's like miniature archaeology. When Stephanie Buck showed me, for instance, a Watteau drawing, which involved a flow of glittering clothes, I could see the precise points, therefore the moments, when the artist had pushed harder, swivelled the point of his crayon to find the sharpest part, then smoothed off into a light fog. In a Rembrandt ink sketch, you could see exactly where he had pressed the nib down hardest into the paper, and where he had chosen to let it skate, and where he had used his thumbnail to scrub out. Yet the Watteau "was" a woman in sunlight. The Rembrandt "was" a carpenter – Joseph, father of Jesus, as it happens – hard at work. All in a brief flurry of lines.

Being completely conscious of the short cut, shorthand notation, and yet being just as aware of what's being shown, provides a special thrill. I have thought about this a lot and I am not sure I understand it. But great drawing doesn't try to hide itself. Van Gogh's stabbing ink lines, or Picasso's huge pencil sketches, delight in showing off the work of the hand, right out there alongside the thing being portrayed. Why does this make us happy?

It's like the difference between reading poetry or good prose, and watching a film. We can enjoy Shakespeare, or Dickens, or indeed J.K. Rowling, telling us about Richard III or Pip or Harry, while both being aware of the words they are choosing, and yet suspending disbelief, moving through those words even as we enjoy their beauty, allowing ourselves to be carried into the story. It's a strange kind of triple tension, involving author, story and reader. Films are, by comparison, generally more of an immersive experience, a hot bath of sound and colour.

Drawing openly says: "here was the artist, working away." The viewer isn't getting a cornfield, or a woman leaning out of a window. The viewer is being offered the record of someone else drawing a cornfield, someone watching and drawing a woman leaning out of the window. The viewer, the second watcher-after-the-watcher, is the final part of the deal. Drawing is franker than painting, more blatant, more open - just as the word choice and manipulation in a poem is frank.

A sketch is an opening gambit. It needs our imaginations to close it, to make it whole. Paintings can be like this. (That's why many respond to the curious oblongs of colour in Rothkos.) But mostly, they aren't.

The difference is emphasised by the drawing's size, and what it is usually drawn on. Collections of great drawings are typically kept in folders or drawers to stop the paper deteriorating, and are brought out to be looked at close-up. (Or, of course, reproduced in books.) The experience of looking at a drawing – you

might even say, reading a drawing – is more like reading a page of a book. It is intimate, one on one. That day in the Courtauld, the pictures ranged in scale from something smaller than a postcard to something as big as a small newspaper sheet. In other words, they were all the size of book pages.

Paintings are typically meant to be looked at from further away – often in a group or a communal gallery experience. They are social experiences. Even a collector, rich enough to own paintings, will want to gather others around to view them together. Drawing is different. I've mentioned that many of the first drawings I ever saw were children's book illustrations; well, in an important way, reading and drawing are intimately related.

Drawings are typically done fast and therefore are more likely to be a record of a passing moment; and that brings intimacy too. In a Michelangelo picture of the crucifixion, the racing, dabbing lines which represent Christ have a nervy provisional energy you would never see in a finished Michelangelo sculpture or painting. Matisse draws nudes with flurries of his wrist, which stay hanging on the paper. Indeed any great drawing is a record of a mind and hand moving at a certain speed, ripping across time and space. Going back to Klinger and Rosand, it is open – a record of minutes in time, rather than a completed glossy object which claims to stand outside time.

Above all, though, drawings are just lines. Whirling blizzards of lines. Lines which magically represent the three-dimensional world all around us.

QUADRUPEDS, AT REST AND PLAY
A horse designed by a committee: a Palestinian camel, drawn with colour added. Below it, to more conventional horses in Argentina: the one on the right is a wild horse, about to try to bite a lump out of the other. Done with a thick, oily 7B pencil.

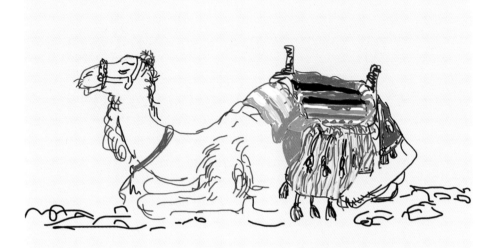

5 THE EYES – DRAWING AND MOVEMENT

Most of us, of course, are not looking out at a blizzard of lines from a single point, a single eye. We have two. The slight difference in their placing, that very important inch and a half, with your nose in the middle, gives us and other animals a sense of depth. If one eye is confronting the rose head-on, the other eye is creeping around it. Everything we see is subtly triangulated as the brain makes its speedy calculations about scale, depth and shape.

For people who are drawing, this reminds us that we are not simply neutral observers, looking out at the rest of the world like bird-watchers crouched in a hide. We are also moving, three-dimensional objects. Any drawing is a negotiation between the things being looked at, and the thing, us, doing the looking.

SELF-PORTRAIT
I look grim, hostile and ill. In fact I am only trying to look hard into the mirror (never, in my case, an entirely happy experience).

Where the draughtsman or painter is placed is just as important in making a picture, as whatever's "out there". We move through our lives like universal centre points, around which everything radiates out, hurriedly re-organising itself. We cannot help it. Nothing is fixed, nothing stable, least of all ourselves.

Even if you try very hard not to move, acquire stillness and fixity, then having two eyes means you are moving, gathering in lines to the same brain from two different places. Ruskin, again, warns that because of this, "Your drawing can never be made to look like the object itself, as you see that object with *both* eyes, but it can be made perfectly like the object seen with one, and you must be content when you have got a resemblance on these terms." As we shall see, some of the greatest modern masters have not been so content.

For anyone drawing or painting, the looking must be intense, as if you are trying to possess what is to be drawn or painted. This is difficult. The more you look, the more you are aware of the process of looking. After a while the more you question what is really going on. It involves selection, which may be conscious or unconscious. The imposed square or rectangle of the paper, canvas or screen is the first selection device. Your drawing cannot continue in space. There are innumerable pictures of artists holding up their thumbs and forefingers to make a rough square, as they squint at a view.

Where are the lines going to leave the page?

PORTER IN THE MAIN ABATTOIR, LIMA.
David Hockney taught me to use plastic Japanese brushes with watered down inks in them to augment fast sketches. And when I'm drawing standing up trying to catch people in movement, every speedy dodge is useful.

In the meat market, Nov 17th.

What will be centred, what left to the sides? We'll come back to the whole question of composition later. But the selection of lines only begins with that. There is also the screening out of innumerable detail, or sometimes the decision not to exclude them. One of the great things about Van Gogh's drawing is his determination to include, for instance, lines of grass or tiny pieces of leaf which most artists would ignore. But most how-to-draw books and lectures, including Ruskin's, spend a lot of time on the selection of the subject. Generally some clear shape, dominating the drawing, is advised.

But what is this thing being observed? Its reality is not the same as what you see because seeing is all about *you*. It's about your brain, and your body. Drawing is the tension between "I" and "the world". Cezanne is the obvious example of an artist who refused to accept Ruskin's assertion that a drawing can only look like an object seen with one eye. He tried to show the looking-round-the-corner effect of real human vision. His stabbing, staccato lines of pencil and paint seek to surround the object as it is presented.

You might think this would create a world of solid, heavy images – particularly as Cezanne loved to paint mountains, large tree trunks and boulders. In fact, it is a world in which everything moves, even stones and rocks. The Japanese woodblock artists called their pictures *Ukiyo-e*, "of the floating world" and although this also refers to floating in the sense of living only for the moment, their tradition too has

HARRY ON TRAIN; LADY IN NEW YORK
Wonderful though it is as a device, there is something about the quality of the line on the iPad which is clumsy, particularly when you are trying to work fast. Unlike a pencil or crayon, the line is the same on each side. The top picture is a bag lady in New York, the bottom one my son, Harry, reading on the train.

overleaf
CARTOONISTS ARE ARTISTS TOO
The larger rump belongs to Steve Bell, the Guardian cartoonist, at work alongside Martin Rowson at a festival of drawing. Does he look any better from the front? Hard one…

a strong sense of endless movement and fluidity. The art writer Will Gompertz points out that by insisting on the importance of binocular vision, two eyes and the fidgeting observer, Cezanne shows that seeing is not believing: "We crane our neck, lean to the side, bend forwards, and raise ourselves up." And yet, he adds, before Cezanne, "art was (and is) almost exclusively produced as if seen through a single, static, lens."

Cezanne's struggle would lead to Cubism. But it all began with intense looking. He said of his eyes, "There's such a strong pull, it's painful tearing them away... My wife tells me they pop out of my head, all bloodshot... When I get up from the painting, I feel a kind of giddiness, an ecstasy, as if I were stumbling around in a fog." [†] Most of us look less extremely. Drawing, using lines to represent things, is therefore an extension of what we do every second of every waking day. But what kind of extension? The hand acts as an extension to the eye, we might say – though wrist, elbow and even neck are involved, along with fingers. But even before the hand is at work, something else has kicked in.

Drawing is a feat of memory. You cannot look at a subject while drawing it. (Try.) You look. Then you must look down to make a mark. Then you look up again, and down again. Every time, the memory is involved. And memory is fallible. If you try to draw something without looking at it, or without looking at what you are doing on the paper, the lines you end up with may well be interesting, but they will be a

URBAN FISHERMEN, ISTANBUL
"Drawing is a feat of memory." Overlooking the Bosphorus, Istanbul. For most of the time I was drawing this, there was in fact a fast white cruise liner blocking the view. I had just caught it, I thought, when it moved off and I had to start again.

[†] Will Gompertz, *What Are You Looking At?* Viking, 2012, page 81

THE EYES – DRAWING AND MOVEMENT

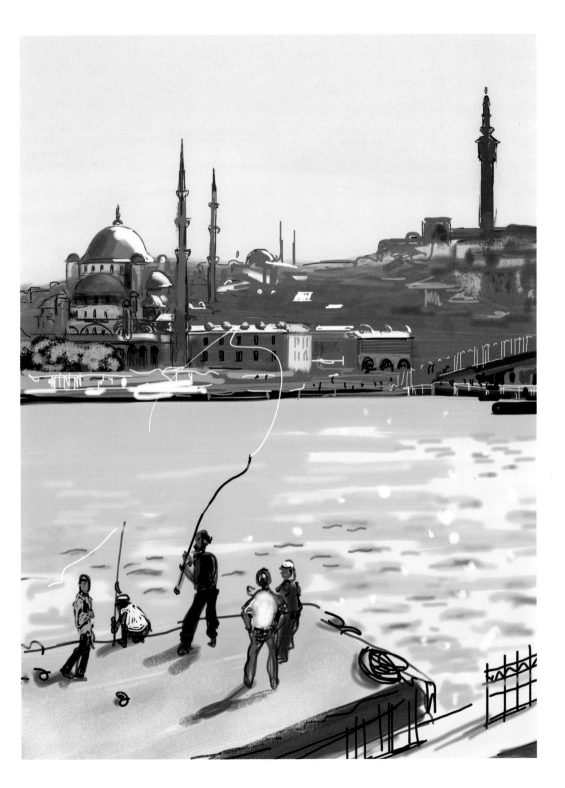

long way removed from what you were looking at. Learning to draw is learning to remember. Learning to remember is learning to look harder.

Musical metaphors can be useful; music is time decorated; time given shape. In drawing there is also a rhythm, a movement in time. How long does the eye fasten on the subject – the tree, the model? How long does the eye then move away from the object to fasten on the drawing? I've watched David Hockney drawing and his rhythm then was perhaps three seconds – five seconds – three seconds – five seconds. Up, down, what he calls "eyeballing". That will produce a different kind of drawing to an artist whose rhythm involves a brief glance at the object, and then a long, absorbed look at the strokes of the picture, or the other way round – a long stare then a brief stab. The rhythm of the eye's movement from distance to near-at-hand surface is embedded in the picture, part of its hidden music.

So right from the start, drawing involves the mind – memory and concentration – and is properly called a discipline, rather than simply a pastime. I was wrong, before. When I draw lines on paper, I am not simply drawing in an external object, as a fisherman pulls in a fish. To draw is to display yourself – your own mind, the quality of your memory and attentiveness. Degas drew washerwomen, and he drew dancers. Even if these were relatively unusual subjects at the time, plenty of others have drawn both. But Degas's washerwomen are bent over, pressing and smoothing and sweating. Compared

to them, working women by lesser artists are just hoops and lumps. He looked harder. He remembered better. Other artists' dancers display interesting shapes; his dancers are up in the air, panting and pushing.

The art critic and artist John Berger once said: "Every great drawing – even if it is of a hand or the back of a torso, forms perceived thousands of times before – is like the map of a newly discovered island... All great drawing is drawing by memory. That is why it takes so long to learn."[†]

Very few drawers will achieve the greatness Berger is talking about, or Degas achieved, but everyone who has any interest in learning to draw must understand that it will involve their own inner essence, not simply their eyes and fingers. It is not like learning to mend electrical circuits. It is more like learning to play a musical instrument; except that from scarily early on, you are also your own composer.

To try to take down the world in the shorthand notation of lines seems a very simple thing. We seem to have an instinct for it. Mankind has drawn for as long as the record goes back. But once you begin, you realise it is also a personal gamble. Hockney likes to quote an old Chinese saying about drawing, that it needs three things, "the heart, the hand and the eye. Two won't do."

[†]Alex Danchev, *Cezanne: A Life*, Profile Books, 2012, page 338

6 THE HAND – DRAWING AND SCALE

We have discussed the eye. Later, the heart. What about the hand? With our memories constantly revising, constantly correcting themselves, drawing requires our thumb-opposable hands, armed with a flint, or piece of charcoal, or pencil, or computer mouse, to note down lines. The lines are an abstraction of rounded reality. Now, the hand abstracts the abstraction. It simplifies further the simplification the human eye has always used to help us get around without being eaten, or run over by a taxi.

The actions of the hand and fingers may seem merely mechanical, the boring toolhead-end of the process. I don't think so. As with a concert pianist, the drawing hand of a good artist learns so deeply

THE STORY OF MY LIFE
I think you can find an almost epic scale in the most mundane scenes. This was drawn late at night in an Australian hotel. I was lonely, sleepless and halfway through *Little Dorrit*.

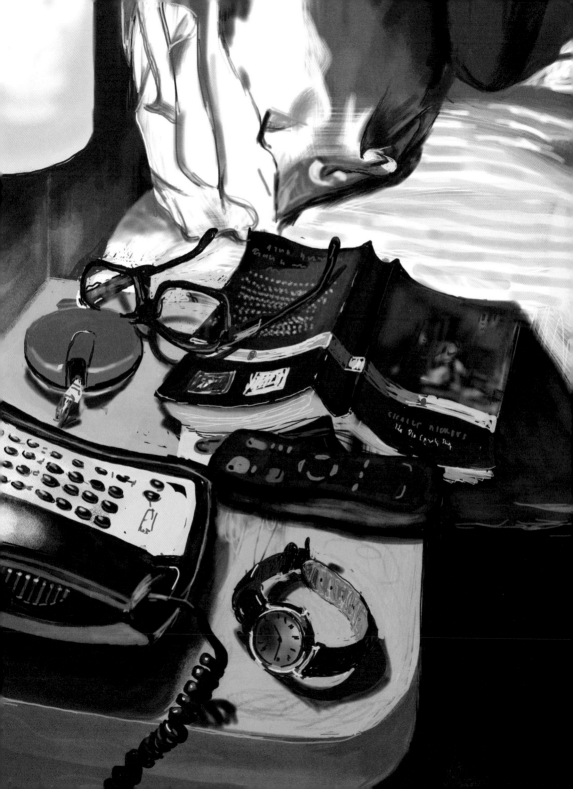

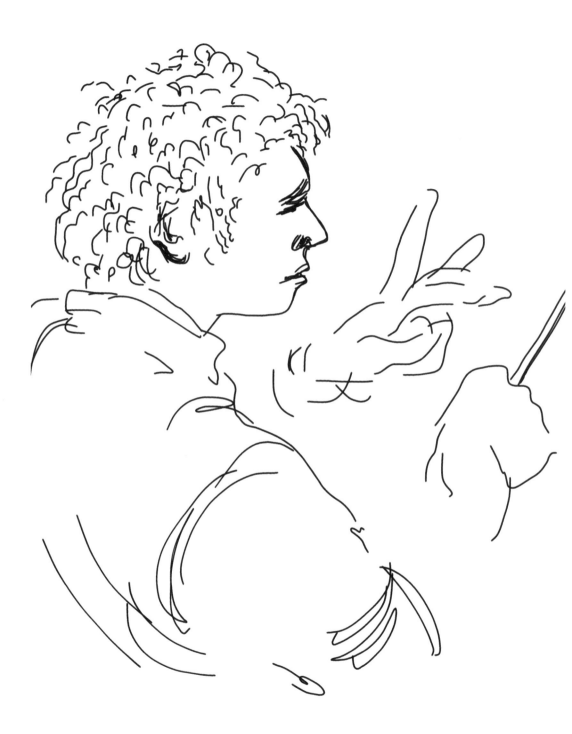

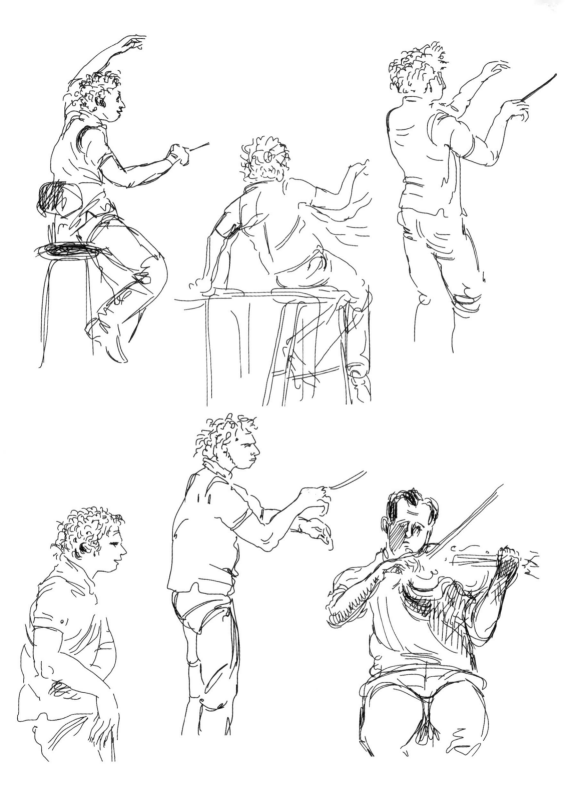

that it seems to have a life of its own. This is accumulated skill and the learning of muscles and ligaments through repetition, of course. Just as a clarinettist's lips, tongue and throat can do things yours cannot, so the artist's thumb and forefinger, and that resting-pushing flap of flesh at the inner wrist, have learned a delicacy, speed and accuracy which beginners just do not have. Watch a really good drawer at work with a pencil. See the feathering, hovering movements, the sudden stabs or sweeps made with odd confidence; it's beautiful.

It is also defined by the scale of the human body, our humble and original measurement of all things. The leaning drawing hand has a range of a few inches; the wristy hand of perhaps up to ten inches; and drawing using the elbow and forearm a couple of feet. Gormley makes swirling drawings using the whole arm-range; they are drawings of energy. But the size of a human being is important always. The mountain may be 3,000 feet high; the drawing of it will be on a humanly domesticated scale. Drawing not only draws in the world beyond us, but mostly seeks to bring it home, at our size.

Is that still true? Matisse famously drew with a brush on a long extended pole, to extend the movements of his wrist and arm on a bigger scale. Long before him, unknown artists on English chalk hills worked on a large scale, cutting back the turf to produce giants and horses. And even their giants are small compared to the hummingbirds, serpents and geometric lines the Nazca people of Peru produced

previous pages
GUSTAVO DUDAMEL REHEARSING WITH THE SIMÓN BOLÍVAR YOUTH ORCHESTRA IN LONDON
I hadn't realised before just how physical and strenuous conducting was. The concentration and "flow" of musicians is perhaps the nearest parallel to drawing. They were going faster than I was.

opposite
PERTH, WESTERN AUSTRALIA
Scale is all about perspective. These are small iPad sketches, only a few square inches in size, but I think the verticals capture some of the exhilarating atmosphere of the city.

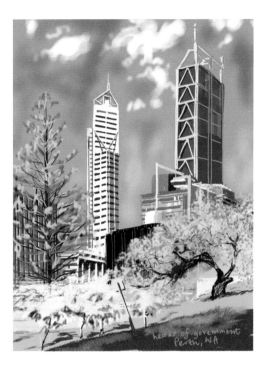

Seats of government
Perth, WA

in the desert, simply by clearing stones. In the twentieth century American earth artists have followed these traditions and "drawn" with mechanical diggers.

Still, most of the time, drawing still involves the hand, and therefore the scale it brings. I don't think this is just about the size of the artist's body but also about the size of the watcher's. The turf pictures of Wiltshire seem to have been messages to be read from far away, perhaps by rival tribes; the Nazca pictures were intended for gods hovering high in the sky. But most of us can only take in so much flat space. Standing still, we are limited by the rotation of our necks. Taking in a picture, we don't want to be constantly moving from side to side like people watching tennis. We don't want cricks. So convenience also dictates the maximum size of pictures. You might think the bigger, the more open and "democratic" but it is almost the reverse. Anyone who has tried to view Michelangelo's Sistine Chapel ceiling knows how hard it is, wedged in a moving mass of humanity, to look up for long enough. The biggest pictures hung in gallery shows tend to have so many people in front of them they are hard to see. Giant art can be exciting, but it works only for particular places at special times.

So even in a world of huge reproductions – billboards or electronic screens – drawing is related to the size of the human body, and in particular the hand and arm. Compared to previous generations, we are much more aware of the limited scale of our

GLASSES ON THE TABLE
The iPad app "Brushes" is brilliant for getting texture. My sight is deteriorating. In fact, my everything is deteriorating.

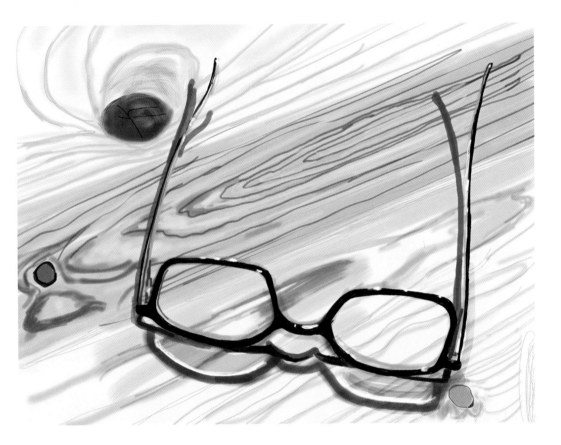

lives. We know about the vast size of the cosmos, and the thrumming complexity of microscopic life. Drawing's knowledge is – mostly – not there. It is on the scale of hand, arm, eye; the small-scale practice of quite small, short-lived creatures.

7 THE HEART – OR, WHAT IS DRAWING ABOUT?

Yet it is not a small art. Drawing and painting make claims on our understanding of ourselves, and on our emotions, that are very large indeed. People don't queue to see a show of Vermeers or Van Goghs simply to admire the skill, and point out how the former used lenses or the latter applied paint direct from the tube. They go because they expect to be touched and, perhaps, changed. It is a commonplace that as organised religion has declined, at least in Britain, art galleries have presented themselves as alternative secular temples. People have learned they must speak in hushed tones there, to avoid laughing, and put on a solemn Puritan face.

A drawing can't forgive your sins. But it has a meaning. It immerses you freshly in the planet you

HAPPINESS IN BEIJING
Beijing is a tough city for foreigners – monumental but rarely joyful. This was drawn in a Confucian Temple, where children are taught the moral basics – "do unto others" and so on. There was a genuinely cheerful and exuberant atmosphere and I am really trying to draw that, not just the tree and pagoda.

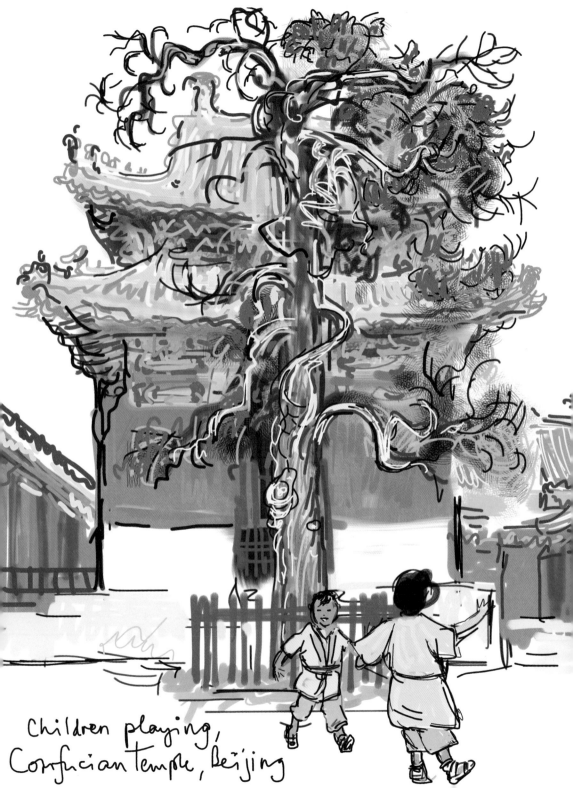

Children playing,
Confucian Temple, Beijing

were born on. When Monet scribbles a few strokes to signify a clump of trees overlooking a river, anyone is able to translate back from his lines on paper, to lines the painter once saw in a three-dimensional world. Without the viewer's ability to re-imagine the drawn lines, to take them in and possess them, and feed on them, so as to picture real trees by a real river, once upon a time – on the Seine, in 1862 – Monet's drawing would be meaningless. To put it shortly, he transports you to a better place.

This is very like written language, of course. Unless the combinations of curves and strokes which say "remorse" or "Philadelphia" are able to unlock mental reactions in the reader, they too are meaningless. But the language of drawing is far older than written language. Drawings of bison, aurochs, or deer drinking, or fish or birds, made during the Ice Age are as precise, instantly recognisable and effective as any drawings made today.

Unlike writing, which evolved from it, drawing has not fundamentally changed. Writing builds on writing. Scripts evolve. Words are lost and made. Soon it is impossible to read back and understand the writing of earlier people. Drawing is cleaner. It's as if every time someone draws they are starting afresh, going back to the beginning. Funeral portraits of Egyptian men and women from the early centuries of the Christian era in the British Museum could have been made yesterday. Scientific knowledge leapt ahead hugely between the time of

THE MONASTERY OF THE CAVES, KIEV
Another religious setting. Here, I was trying to draw tranquillity and calm. It's a very special place – and a very cold one.

THE HEART – OR, WHAT IS DRAWING ABOUT?

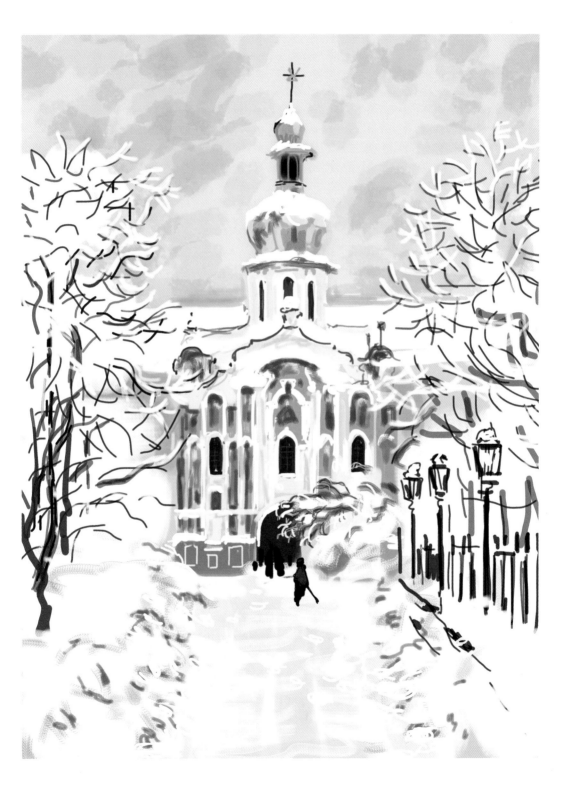

Galileo and of Einstein. But the drawing of Galileo's contemporaries, such as Rembrandt or Caravaggio, is more skilful than the drawing of Einstein's contemporaries, bar perhaps Picasso and Matisse. What delighted them then, delights us now.

We have already looked at some of the sources of that delight. But one fundamental pleasure has simply been drawing as a crutch for memory. The hunters wished to remember (and maybe to honour) the animals they killed, and some who escaped the spears. Before the invention of chemical-fixed photography, people needed drawing to remember the faces of their loved ones. Drawing was also a source of information about the far-off. People could see what their monarch or pope looked like. Dürer's drawing of a rhinoceros is not only wonderfully expressive – even though he probably never saw it first hand – but was popular because when printed it allowed so many people to have an idea of a beast they had no chance of meeting.

Drawing was also narrative – the modern fashion for graphic novels goes back to carved tales of the Buddha's life in India or the sculpted saints and stained glass windows of French cathedrals. From terrifying Creation-myth creatures in Mesoamerica to Renaissance altarpieces, drawing was essential for illiterate people who wanted to remember and so to understand.

It's useful to remember this basic, universal aspect of drawing, so we don't get too hoity-toity. But having said that, let's get just a bit more hoity-toity.

For drawing as information remains powerful long after the invention of modern photography and film. Why? Because so often it can note down something which cannot be done any other way – not with a click of a mobile phone camera, nor in words. Lucian Freud made a drawing of a once-famous lawyer called Arnold Goodman. I never knew him, but the drawing records a noble, fleshy, sly, exhausted fighter's face. The longer you look at it the more you understand about Goodman, in a way nothing else can quite bring home. Or think of Samuel Palmer's famous drawings of English moonlit nights. The mix of homeliness and alienation, smallness and a cosmic scale, simply could not be brought any other way. It goes beyond recording, or drawing-as-information.

David Hockney cites a fast pen sketch by Rembrandt as his favourite drawing. It shows us not only two women helping a toddler to walk, but the love and anxiety of the adults and the proud determination of the toddler. Yet there's almost nothing there. It's a few brisk strokes which must have taken him around 20 seconds or so. I cannot think of any way the scene could have been done in mere words.

One lesser-known artist I love is William Gillies, a painter of Scottish landscape in the latter half of the twentieth century. In his drawing he can show the undulations and subtle textures of farmland and hillsides so that it gives anyone who is at all sensitive to these things a warm glow and chuckle of admiration

and a "yes, it must have been *just* like that".

Phil May, the *Punch* cartoonist of late Victorian times, doesn't seem very funny these days. But his ruthless pencil caught the look and feel of scummy London streets, and scummy Londoners, with a directness that still makes the pulse race. He could do with a few twists of his wrist what it took a good prose writer of the time, such as Henry Mayhew or Jack London, scores of pages to accomplish.

Before Rembrandt, Hockney, Gillies or May, however, drawing starts by being more about two kinds of information than any other. Its subjects are religion and power.

The great national art collections are full of pictures which were once made to be part (and a minor part) of religious services, but were removed from churches or monasteries and sold to collectors. At that moment, the point of the pictures changed. They ceased being a means to an end, a machine for encouraging meditation about paradise, death, the good life or the temptations of the flesh, and they became things to be worshipped in their own right, for the skill and beauty of their making. They may be cherished but they are hollowed out. It is as if we went to see exhibitions of cars purely to admire their lines and colours, forgetting that they were once used to get around in.

Some of those who first commissioned the altarpieces were already opening the door to ambiguity about their real subject. By showing off their success in being able to pay for the latest, most

TONY BLAIR LOOKING UNHAPPY, SEPTEMBER 7, 2006
I very rarely draw anything to do with politics, though I spent most of my time thinking about it. Here's a rare exception. Tony Blair looked haggard and at bay just before he was forced out of Downing Street. I freeze-framed the BBC news channel to try to get his face right.

overleaf
MARATHON – THE PLACE, NOT THE RACE – IN THE RAIN
Setting counts; without it this is just a view of trees on a sandy shoreline, drawn from a car as the rain came down. But this is where the Athenians and their allies defeated the much larger Persian army. The site of the first great victory of democracy, it is hallowed soil.

Sept 7th 6am. Up + take Harry to King.Cross for his visit to Leeds Uni. lump in throat. Jockie working on the Blair-Brown crisis. To White City for Panorama briefing. Brown still on for Sunday. Blair's ½-admission that he won't see another Labour conference dominates all day. Frenzy.

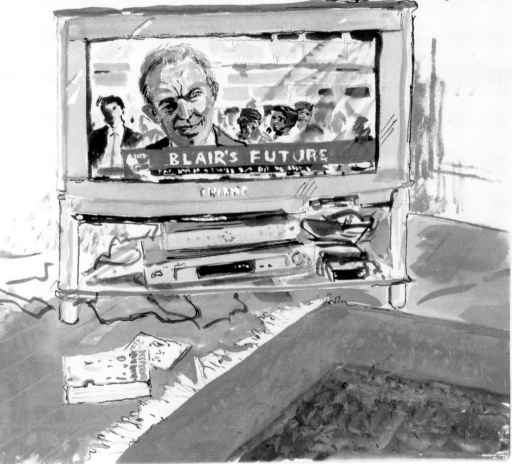

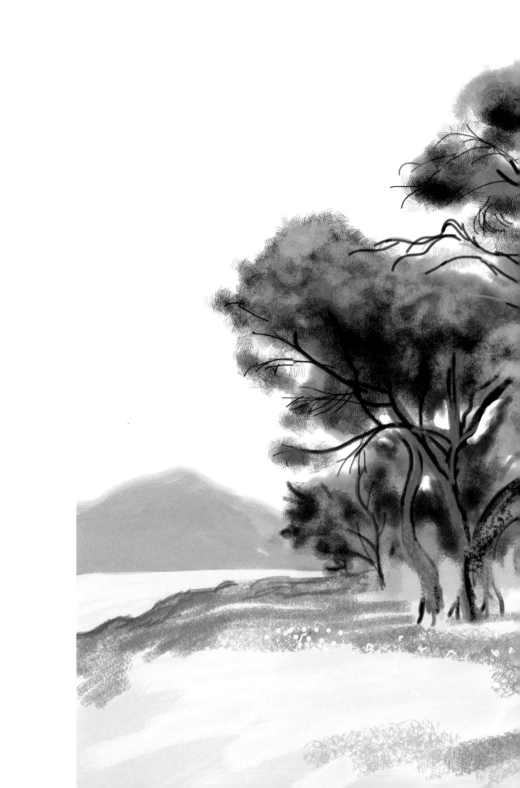

Marathon in the rain

heavily gilded or flashiest pictures, patrons were (consciously or not) focussing attention on the artist's skill. Soon, religious painting is paired with paintings of classical myth, and both start to look as if they are really paintings about people – about love, sex, drunkenness, old age, cruelty, parental joy. The application of wings, or a Biblical caption, allows images of much earthier, here-and-now subject matter. But the God problem never quite went away. It was pointed out by the director of the British Museum, Neil MacGregor, when he ran London's National Gallery. In 2000 its exhibition of Christian art, *Seeing Salvation*, attracted huge numbers, including church groups, some of whom prayed in front of images which had been taken from their original settings and converted into "art history" in the gallery.

In some circles, there was a shocked reaction, as if this was a blasphemy against the new religion, that of high art. But drawing and religion were interwoven from the start. It may be that the beautiful drawings of animals on Ice Age caves, or on bone and ivory, were connected to shamanistic worship of animal spirits. I don't know what percentage of all art we could call religious art but if statues and friezes are included, it must be the majority.

Power comes next. As soon as named rulers appear in Mesopotamia we have chiselled drawings about them and their doings – the Assyrian lion hunts, the gory sieges. Later, every two-bit ruler

from Edo to Erfurt wants pictures of themselves, cramming today's galleries with portraits.

But these are not simply acts of self-glorification. If they were, they would be duller. They are also information. If you really want to know what Henry VIII was like, go and look at the Holbein drawing of him in the National Portrait Gallery, and the contrast between the hanging pork swathe of his face and the mean, puckered little mouth. Hans Holbein the Younger, by the way, the German who came to England, was a drawer of unearthly skill; the chalk drawings of Tudor courtiers or continental friends are done with a sureness of line, a crisp certainty and a psychological insight that has never been matched. Kings and queens sent portraits like snapshots before betrothals. Later, royal portraits, copied to provincial mayoral homes or estates, would show subjects what the faraway boss looked like. Popes and Doges, Elizabeth I and Charles V used them as essential propaganda – with varying success.

8 WHEN DID NORMAL PEOPLE START DRAWING?

They always have, of course, from caricatures hacked into doorways to scribbles on the edges of spare paper. But as an acknowledged habit or discipline, by more than special, paid picture-makers, drawing arrived after the Renaissance. The idea that it might be good to learn to draw even if you were not decorating altars for monks, or paid to record the fat thug who had taken over the city, seems to have bubbled out of Italy, with Castiglione's 1528 best-seller *The Courtier*.

Professional artists had long drawn, to practise their skills, to note down scenes from everyday life and above all to design their paintings. Tucked away in a private room inside London's National Gallery there are two vast and astonishing drawings by the

A BRONZE OF LAOCOÖN, ROYAL ACADEMY, 2012
The old academic system of learning to draw by copying casts and statues has almost vanished. But if you really want to understand something, drawing is a great way to start. This was done at the Royal Academy's exhibition of bronze sculptures. They have a drawing school and they kindly provide fold-up seats for anyone who wants to sketch.

Italian painter Agostino Carracci, one of a famous family of artists. They were made as designs for the Farnese Palace and, as with many Renaissance drawings, they were "pounced" – that is, tiny holes were pricked along the lines so that charcoal could be blown through them, transferring the image to the wall or ceiling. Today's director of the gallery, Nicholas Penny, argues that there was a second stage: that pounced image was then carved with blades onto the wet plaster, falling to pieces.

By the mid-Renaissance, however, some drawings were valued highly enough in their own right to be collected and passed around; some were used to help train younger artists, and rich patrons kept drawers of them to pore over. Painting was a mucky, grinding-and-mixing, smelly and slow affair, but drawing allowed amateurs to develop a little skill of their own.

Some highly finished drawings by, for instance, Michelangelo are thought to have been intended to help aristocratic patrons learn; and a painting by Parmigianino shows a nobleman actually drawing. In his handbook about gentlemanly accomplishments, Castiglione included drawing among the essential skills of an aristocratic man. Translated into English for Tudor readers by Thomas Elyot, Castiglione argued that drawing encourages the expression of idealism, "the imitation of virtue". He is not suggesting that gentlemen become professional artists "openly stained or imbrued with sundry colours, or powdered with the dust of stones." Far from it. Drawing should be used

"as a secret pastime or recreation of the wits" – in effect an exercise in mental self-improvement.[†]

Soon after this Nicholas Hilliard, the foxy-faced goldsmith and creator of miniature portraits, wrote what the scholar Ann Bermingham calls the first portrait of an artist by an artist written in English. A gentleman himself, he also thought drawing should be a private act but as a doer went further than Castiglione. Drawing, thought Hilliard, is natural and irrepressible, growing out of the artist "as hair out of the head." He calls it limning, which means drawing or painting on paper or vellum. Limning portraits, which requires a clean, calm and careful artist, has a beneficial effect. It "breedeth delight… removeth melancholy, avoideth evil occasions, putteth passions of sorry and grief away, cureth rage, and shortneth the times." This may make it sound like a combination of a cold shower and a hot toddy but Hilliard is quite right: *drawing is good in itself, and not only for the things it leaves behind.*

By the time of the British Civil Wars, the countries of today's United Kingdom were awash with printed paper. Ballads, tracts, primitive newspapers and handbills often came with woodcut drawings. Expensive paintings bought by the rich and powerful from Flemish or Italian artists might be crudely copied in books. Drawing had always been important for architects but as science began to advance, it became an important skill for mathematicians, anatomists, collectors of botanical rarities, designers of military fortresses, astronomers

overleaf left
SNOW, HAMMERSMITH, 2008
By Hammersmith Bridge, London. I love drawing snow. Luckily there was a pub with a corner seat and window.

overleaf right
BRIDGES OVER A MANCHESTER CANAL
I skipped away from a Labour conference to draw this. There's not a lot of industrial Manchester left.

[†] *See* Ann Bermingham, *Learning to Draw: Studies in the Cultural History of a Polite and Useful Art*, Yale University Press, 2000, page 17

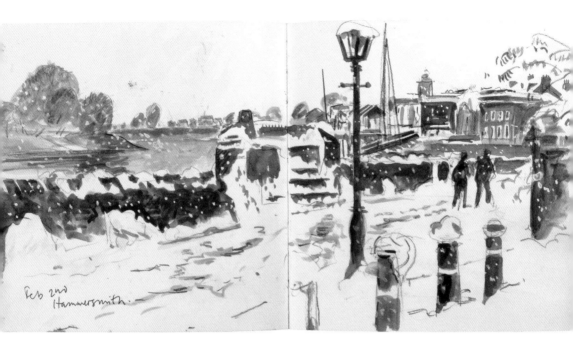

Feb 2nd
Hammersmith.

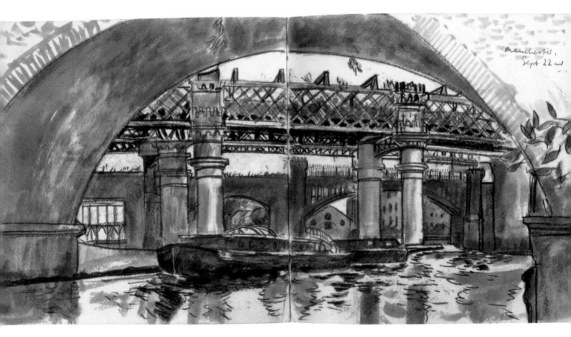

Manchester,
Sept 22nd

and the first men to peer through microscopes and sketch the weird world of wriggling little creatures and hidden structures. Suddenly more and more people are sketching as a kind of quick verbal information – pictures of Londoners rowing boats, ladies dressed up for masques, players on the stage, shipping and those flashy new stately homes.

It is only in the 1700s, though, that the real drawing craze spreads from small numbers of enthusiasts to the new middle classes. Some of this continues to be for basic practical reasons – here's what the natives in India look like, here's a topographical survey of that wild frontier of Britishness, the Scottish Highlands, here's my idea for a steam engine or new kind of plough. Technical drawings can also be spectacularly beautiful; think of today's architectural drawings. But as with Castiglione and Hilliard, there is a higher purpose too.

Drawing will make you a better person – not morally, necessarily, but it makes you think. It will help you see the hidden patterns all around you, and make you a discriminating lover of landscape, faces and mundane objects. It becomes an education, which changes your brain as much as learning to play the piano or to dance. It is about striving to become more fully human.

This is understood by many people who draw today. By the eighteenth century, the practice of learning to draw from nudes was well-established across Europe (though nowhere else) and part of the reason was that studying the human form produced

an idealised sense of humanity's beauty and possibility. At the end of 2012, A.A. Gill, the television critic, who was himself trained as an artist, wrote about life drawing for *The Sunday Times Magazine* and described a male model who had stripped: "The boy steps up onto a yard-square box and performs a small, unconsidered transformation that is one of the most profound in all civilisation: he steps up from being naked to becoming nude. Naked is to be without clothes...you get naked for a lover; strippers and corpses are naked. Nude is the reveal of humanity, our collective apotheosis."[†]

By the eighteenth century in Europe, drawings are suddenly everywhere. Coloured prints of everything from lewd scenes at the theatre and rude political cartoons to romantic forest scenes and mountain vistas are bought in huge numbers at specialist shops. While in London, there are strenuous attempts to create a serious "British school" of fine art painting to rival the achievements of the Dutch and Italians, thousands of amateurs are setting out with pencils, paintboxes, easels and blocks of paper. They are buying "how to draw" books, full of designs to copy, explanations about how to compose your picture, and exercises in cross-hatching and learning to draw smooth lines.

By the beginning of the 1800s painters of the genius of Cotman and Turner are among the hundreds of artists who work as drawing masters, holding lessons in town houses and schools, or travelling round the counties, teaching sons and

[†]A.A. Gill, *The Sunday Times Magazine*, 30 December 2012, page 14

daughters. Many watercolour societies, sketching societies and drawing clubs begin to spring up. Today's drawing world of art shops in small towns and life drawing classes in the local college, that naked-into-nude transformation Gill described, starts here.

More and more of the people sketching were women, kept out of so many pursuits, who now find that drawing is not only fun but gets them out, to places they might not otherwise see. They draw each other. They draw their homes and towns. Under parasols they draw foreign scenes. Some of the amateur drawers would use camera obscuras or camera lucidas to help form their compositions. Others used "Claude glasses", as a kind of rear-view mirror to compress a scene into something easier to picture. Most probably just used their hands and eyes and hearts.

Today, we have been well educated to understand that most of us cannot draw. In the nineteenth century, foolish folk, they did not realise this, so they went off and drew anyway. It was a great time for amateur art and we are still feeding off its leavings. These people were drawing to inform other people, to illustrate letters and to send pictures of growing children to far-off uncles. Some were drawing because having the leisure to do so proved you were middle class and on the up. Unlike the artists who had started the drawing movement, they were not drawing to think their way through larger compositions in paint. But most people were drawing to explore...beauty.

A BAD DRAWING
Here is a failure. Drawn in Venice, the colours are cheerful enough but the perspective – I was sitting on the ground – is dreadful. Look at the buildings on the right!

9 BEAUTY

Much of philosophy, Western and Eastern, is devoted to beauty, or "aesthetics". We don't need to be philosophers to be interested. Most of us have some basic emotional reaction to colour and shape, even apart from the immediate information they provide. Being pleased by a red bus because it will carry you home is pleasure, but it is not aesthetic pleasure. Being pleased by the contrast of a bright red bus against a bright green hedge is. Enjoying a drawing of your partner because you love them, and enjoying the drawing rather – or also – because of the elegance of the wispy charcoal strokes it's made of, are two quite different things.

Artists and art lovers have always understood this simple distinction; otherwise Titian's search for a

TREE IN STRONG WIND
An oil painting, done near Otterton in Devon. Another favourite tree. I nearly gave up: a gust of wind flattended the canvas and I had to spend an hour or so picking out flies and pieces of grass before carrying on.

Towards Colaton
Raleigh
27 July '07

particular deep-glowing blue colour, for instance, would have been pointless. All that abstract artists did was to yank apart the pleasure of the object recognised and the pleasure given by shape and colour, and work with the latter. To do this well is very hard.

However, beauty is a feeling or it is nothing. It is triggered by the art work – the vibration of strings, or the curve of a statue – but it happens in the human brain. (And, I hope and think, other brains too.) At best the experience is a light-headed exaltation, a buzzy trance of happiness at being alive. The pulse rate rises, the pupils dilate – the classic signs of arousal. Beauty arousal is parallel to sexual arousal, but despite all those tales from artists' studios, it isn't sexual arousal. It is more like an up-swelling of love. I take it that's really why people go to art exhibitions or indeed for walks in beautiful countryside – to get that happiness-shot, to feel in love with the world, to be alive vividly and sharply.

The poet Glyn Maxwell, in a recent book on his art, argues that there is a kind of base-beautiful human landscape, which consists of grassland with trees, and a river, and which goes back to our early evolutionary origins in Africa. Psychologists have found that it "works" better when people are asked to choose, compared to other landscapes, of jungles, beaches and so forth. Maxwell reports that the evolutionary psychologists think what we are responding to is simply what we need to live: "an open space (we can hunt) with trees (we can hide)

THE ELEMENTS OF A "GOOD" VIEW
An open space with trees and water. Okay, it's overlooking Central Park, New York again, but I think the range of colours and variety make it a classic "pretty" view.

BEAUTY

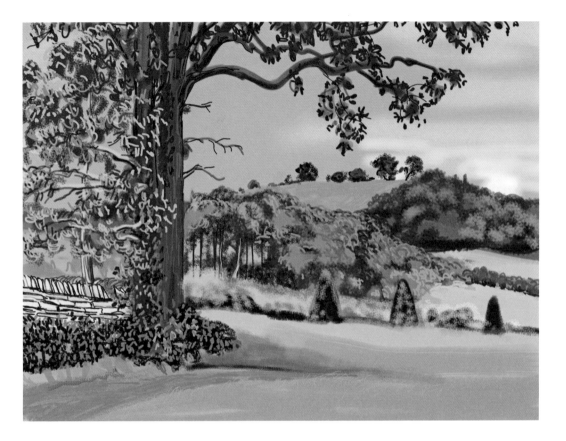

whose branches spread out near the ground (we can escape) and bear fruit (we can eat). We see a river (we can drink, wash, eat) or path (we can travel)…" His analysis goes on, but ends with his conviction that the things we find beautiful "originate not in what renders life delightful or even endurable, but in what makes life possible." [†]

Does that ring true? Thinking of landscape pictures, I'd say the most popular skyscapes would involve bright blue, with a few scudding clouds – so good weather, warm on the skin, but also the promise of nourishing rain at some time. Uniform blue, despite the holiday adverts, is less interesting. Most of us get a particular kick out of rich greens and earthy reddish purple, the colours of fertility, and the golden-yellow of ripening grass and fruit. The branching shapes of trees to attract the maximum sunlight are one of the universal patterns – like the structure of lungs, roots, coral and mathematical solutions. But there's more to it than that.

Our physical position is that we are a few feet high, balanced vertically on our hind legs, and this gives us a few elemental markers. To us, the horizon line, indeed lateral lines generally, are the ultimate reassurance. For a vertical creature, vertical lines – trees, mountains, waterfalls – spell both dangers and opportunities. We once came from trees, and trees, with branches and fingers, are our spectres, our familiars. Diagonal lines, jagging up or down, tend to suggest disruption or at least change. We are natural hunters, looking out for movement in

previous pages
left
FEBRUARY SHADOWS IN RICHMOND PARK
Trees provide a visual metaphor for the human body and indeed the arc from sapling through adult strength to decay and death. I guess that's why so many go back to drawing them endlessly.

right
BACK TO THE DRAWING OF TREES, FOR THE OBVIOUS REASONS
Also, they don't whine, "but you've made me too fat". This is at Hay-on-Wye, famous for its literary festival. And its rain.

[†] Glyn Maxwell, *On Poetry*, Oberon Books, 2012, page 10

complex, light-speckled environments; and we still tend to respond more alertly to moving views.

None of this is to say that other colour and shape combinations do not work for us too, at certain times and certain moods. I find the reds, bronzes, golds and browns of a British autumn very moving. It's my favourite time of year. I suppose that is something to do with ageing and aching, the enjoyable melancholy of darker nights and more slanted winter light. As the leaves fall, we not only get bright colours which are about to disappear but find the trees stripped again to their inner patterns, while the earth seems closer and smellier. The great Russian painters of the nineteenth and early twentieth century were particularly excited by early spring, the first thawing, and the earliest return of sharp, bright greens. There is not one ideal landscape gifted to us by our evolutionary past. We observe and adapt all the time. Northerners have to live through huge seasonal changes and it makes sense that our ideas of beauty have those at their core.

All the theories of aesthetics, from Aristotle's writing to Hogarth's serpentine "line of beauty", all the arguments about harmonious proportion, symmetry, balance, through to theories of necessary imperfection and subtle imbalance, build on our basic emotional reactions to colour and shape. These relate to other animals and each other as well as to landscape. The bulls and elephants of early art carry a pleasurable shiver of menace. Once people argued that we find a smooth and symmetrical face beautiful because it reflects Divine perfection; today,

others say it's because such faces imply a strong, disease-free genetic health. Changes in ideas about human beauty, as for instance the enthusiasm for big-bellied, big-buttocked women in many earlier and poorer societies, representing food success, do suggest sexual selection is crucial.

That first drawing craze was intertwined with a self-conscious search for beauty. Much effort was expended on demonstrating ideal landscapes, with the "correct" balance between uprights and horizontals, and foreground, middle distance and background. Detail went out of fashion, then returned again. But this was not about primal human needs and certainly not about evolutionary psychology – not for eighteenth- and nineteenth-century sketchers. It was about goodness and truth. Behind it all was a vague memory of Plato's ideal forms. For Christians the stamp of divine perfection was, perhaps, still just visible all around us if you knew where to look, and how to look. For the new Pagans, too: Keats's "Beauty is truth, truth, beauty – that is all / Ye know on earth, and all ye need to know" became a battle cry for several generations.

Today, it is hardly surprising that we are returning to the old territory of beauty and truth, but via evolutionary psychology, rather than classical philosophy or religion. Yet we are a little more nervous. We often shrink from the words beauty and beautiful, as if they are suspect, even tainted. We have come close to reversing the Keatsian sentiment. If something's beautiful, then we think that at some

DRAWING WHILE WALKING
Most of us who draw are the inheritors of the 18th-century landscape drawing craze, at least at times: this was done in black chalk and very fast during a walk at home in East Sheen, London, when I tried to stop every 10 or 20 minutes to sketch what was in front of me.

level it must be untruths. A "lovely" picture is inauthentic, ersatz, lazy, sentimental. At least in the high temples of modern art, people want it ugly, raw and angry. Why is this? One way of answering the question is to return to that earlier one: what is drawing *about*?

10 DRAWING AND UNHAPPINESS

After the drawings of saints and monarchs, and all the drawing that was basically informational – here's a rhinoceros, here's a map of Savoy – we get more and more drawings of landscapes and people. The people are no longer simply the most powerful, but anyone who can afford to pay to be recorded. Soon artists insist on including peasants, fortune-tellers, drinkers in alehouses and tinkers. The landscapes in Europe move from being a personal record of the Duke's acres and new house, to being images of rural life generally.

It cannot be a coincidence that the great age of landscape painting, beginning with Hobbema, Rubens and Dutch Golden Age artists, then running through Constable, Cotman and Turner in England,

LONELINESS DRAWING
Nobody would confuse me with a cheery little bunny here. Deliberately bleak and ugly, this is a record of a lonely late night in a New York hotel.

and lasting until around the First World War, particularly in France, covers the migration of agricultural societies to the town. Throughout all of human history, people had lived in woods and grassland, gathering and ploughing. Now, suddenly, they are on the move, but their memories remain among oak trees, winding rivers and villages clustered round crops.

What else is being painted? As soon as there is a middle class they are recording their new stuff – rare and expensive flowers, porcelain brought from the Far East, showy silk and satin clothing, mouth-watering food, Turkish carpets and expensive furniture. Beautiful pictures are pictures of things which are beautiful.

But as time went on, more of the picture-making had a political, darker edge to it, as the cities become larger, and contain greater disparities of wealth and more anger. In Rome Piranesi's images of imaginary prisons, beginning in 1745, coincide with Hogarth's images of executions, prisons, drunkenness and folly in London at the same time. Half a century on, and Goya will be making his terrifying images of lunatic asylums, and later the tortures and killings of the Napoleonic wars. Later still will come Gustave Doré and a host of realist painters, recording misery and poverty. Even art which now looks easy on the eye often turns out to have a political meaning.

Constable was recording the changes in East Anglian landscapes, as enclosure changed the look of fields. Monet and the anarchist Camille Pissarro

MUMMIFIED WARRIOR
Well, this is reasonably dark. The mummified body of an ancient Nazca warrior, screaming at us from a glass box in a Peruvian Museum. Where's Francis Bacon when you need him?

Caught Nazca: Museo Regional de Ica

were consciously recording change too – trees about to be cut down, valleys with railways running through them, smoky factory chimneys fingering the skies behind allotments and rivers rammed with barge traffic.

This doesn't obliterate old ideas of beauty. Piranesi has to hold the viewer's eye. He does it with rich contrasts of tone and complex patterns, learned from his earlier studies of architecture. Hogarth's angriest scenes are meticulously composed, following his own theories of beauty and line. Goya was a master of thin, apparently loose but perfectly chosen brushstrokes – only to be rivalled later by his great admirer Manet. His horrific aquatints on "the disasters of war", so provocative they could only be shown more than 30 years after his death, are superbly composed and delicately drawn. Later overtly political artists, such as Käthe Kollwitz, whose etchings are as finely drawn as those of any Renaissance master, knew they had to hold attention with good line, balance and variety if they were to make their protests work.

So as the range of people who could look at art, or buy it, increased, the subjects of art expanded. Sold as images in newspapers and magazines, or viewed in free public galleries, art could be about unhappiness, unfairness, war, torture, mundane sex, crime, anything you liked – or didn't like.

Today, for many people, traditional landscape or nature painting is outdated and even false. Most of the seven billion of us alive live in crowded cities, far

from landscape. Car-makers, holiday companies and food manufacturers toy with our sense of loss by setting their adverts among unspoilt-looking fields and hills, or sun-splashed Mediterranean olive groves. Surrounded by so much cynical commercial imagery, art which celebrates natural beauty can seem sentimental too. We are more aware of the countryside as a place of change and conflict, from arguments over fertilisers and GM foods, to depopulation.

This doesn't mean that the celebration of natural beauty, and our place in the world, finishes – once it does, we are finished too – but that the search for new ways to express it, new subjects, never stops.

11 DRAWING AND CHEATING

What is drawing, and what is cheating? Is it cheating to copy? Is it cheating to trace? Is it cheating to use a mechanical helper? And by the way, is cheating an appropriate word in the first place? I include this short section only because lots of people wonder.

We can start at the Frieze Art Fair in London, in October 2012 where art dealer Daniel Blau was very excited. He had been looking at some early drawings by Andy Warhol, which had lain undiscovered in a chest of drawers since his death 25 years earlier. These are some 300 drawings he made at the start of his career, in the 1950s, and kept all his life. Unlike later Warhol images, which are traced from photographs, these are freehand drawings, of children, a man reading, heads and a dancer.

EDGE OF SOMEONE ELSE'S POND
Cheating? My sketch of a fragment of one of Claude Monet's famous late waterlily painting "Les Nymphéas". They are pictures about the passing of time and need hours to appreciate properly. When I was last looking at them in the Orangerie Museum in Paris, hordes of people were pushing in, photographing them and leaving within a minute or two. Why?

Mr Blau says that when he saw them they "stole my breath at first, then made me drunk with exaltation." He likens them to Priam's treasure and the work of the Old Masters. This, from the illustrations in *The Independent* (October 2011) seems to me to be overdoing it a bit. But they are more than competent and above all, already Warholesque. He is fascinated by the outlines and silhouettes of things, and by the decorative effects of hair. There is something fey and 1890s about the drawings, as there will be in Warhol's famous later portraits.

What this really tells us is two things: Warhol had an identifiable hand from the beginning, and he really could draw. Warhol is interesting, however, because he raises this question of "cheating". Some art critics have expressed utter contempt for his "factory" approach to making images, both the use of delicate, nervy line to trace and then decorate or re-colour famous pictures by others, and the machine-like production line.

Elsewhere in London at roughly the time the new Warhols were being discussed, other people were queuing to be drawn by a computer, "Paul". Paul had been programmed to produce tangles of lines, working off light and shade with a mechanical arm and a ballpoint pen to make an image of faces. The results of this cybernetic sketcher were odd, but recognisable and above all cheap, at around £30 a pop. Its creator Patrick Tresset who built it for less than £300 said he hoped to secure funding for robot artists with greater skills. Again, is this really drawing?

Artists have used mechanical tools and aides of all kinds. They have used light-boxes and lenses of all sorts, squared lattices, spray-guns and, yes, computers. Artists have also always copied. They have copied each other and copied themselves. Van Gogh painted "after" Millet and Manet "after" Delacroix, Picasso after Velázquez and Bacon after Van Gogh. The appropriation, copying, transforming and exploiting of images is fundamental to art history. Renaissance painters would study one another's sketches and completed work, using them as models. They would complete large freehand sketches of their own, and then pierce them so that chalk could be rubbed on, transferring the lines to a canvas or piece of wood, for the painting itself. So aides are neither here nor there. Nor is the quotation and reworking of somebody else's picture.

The only question is aliveness. A lame, mechanical copy of another work is a lame, dead thing. Most of us, even subconsciously, can tell. The drawing must say something about the drawer as well as the thing drawn. Warhol's drawings, however they are done, say a lot about Warhol: cheating is indeed a completely inappropriate word. He is not forging, or trying to pass anything off as his own work. As to the computer, however, it can tell you about computing. It can tell you about programming. But it cannot tell you about drawing since drawing is part of human consciousness.

12 THE SHATTERED URINAL SHOWERS US ALL

A century ago Marcel Duchamp, the original conceptual artist, yanked apart the skills of drawing, painting or sculpting from the idea of art. We are still recovering. By signing a urinal, or by fixing a bicycle wheel to a chair, he declared that the job of the artist was to bring ideas, or concepts, before the public. How those ideas were conveyed, the witty Frenchman thought, mattered less than getting them across. Glass cases of objects or written notes could be more effective than flat spaces covered with paint.

The whole subsequent history of video art, performance art, art made of rubbish, smashed cars, or of bricks, the art of fried eggs laid on tables, unmade beds, pickled sharks, sets of instructions written on cards, of live butterflies, of sculptures

MODERN ABORIGINAL PAINTING
Our Western tradition of representative art is in danger of taking over our understanding. This looks like an abstract painting to us. In fact it is a copy I made of an Australian aboriginal picture which shows a group of men and boys "just sitting around minding their own business" when they are approached by some "wicked women".

fabricated in workshops to the artist's instructions –
the art that by and large delights *Daily Mail* headline
writers and *Guardian* arts writers – has emerged like a
vast, glittery spout of magma from Duchamp's urinal.

Cheerful magma? Horrid magma? Something
rather worse than magma? Conceptual art goes
beyond my chosen subject. But because it has so
radically affected the status of drawing and painting,
a brief digression about it is needed. There is video
art – for instance by Bill Viola – which is as moving
as any painting made in the past century, and there
are many conceptual artworks, such as the doom-
laden, shamanistic, unsettling pieces by Joseph
Beuys, which only an idiot would dismiss.

Yet two things are almost immediately obvious to
anyone who turns up and actually looks. (Never, *ever*,
take the word of any critic of art about *anything* if you
haven't seen it yourself.) First, the conceptual art that
tends to immediately impress, and perhaps then to
stick in the mind, is not conceptual. That is, it is not
simply a conveyed idea. It has form, heft, colour,
texture; there's something to see. It may even have
beauty. Richard Long has made art out of walking;
except that what you see are the beautiful sculptures
made out of natural objects he finds along the way, and
the photographs of them, as well as information about
his walk. He has not picked up a pencil and taken a
line for a walk; he has taken himself, almost as a pencil.
Damien Hirst's floating, pickled wool of a bisected
sheep, or his diamonds on a skull catch the eye. They
are nothing like pure idea. Aesthetics forces its way in,

**WHERE IT ALL
STARTED**
The first cave paintings,
were I suppose, as
much conceptual as
representative art,
being "about" spirits in
the natural world. This
charging prehistoric
monster is in fact a
cave in South Africa
where we were filming
the story of the first
migration of humans
from the continent.
There were some
beautiful drawings
of elephants made by
bushmen nearby.

THE SHATTERED URINAL SHOWERS US ALL

always. Because we are seeing creatures, colour and form are stronger, more primal, with sharper elbows and louder voices, than any conceptualism.

Second, if an artist is going to claim that his or her ideas, rather than skill, long observation or talent, are central, the essence of the art… then the ideas had better be good. That is, they had better be rather more interesting than "hey, we all die" or "money corrupts". The idea, or concept, doesn't necessarily have to have a profound philosophical or scientific point.

Tracey Emin's autobiographical work has taken a large slice of contemporary English life – that of young women in rough, marginal places, with all its pathos and courage – and by carrying it to the Tate, the Royal Academy and the Venice Biennale has rubbed it into the imagination of smugger, luckier people. That is an idea. Hers has been a war against condescension. Grayson Perry, the transvestite potter, has depicted feral, sexually-abusive scenes on his beautiful vases and tapestries. Like Tracey Emin, his ideas involve showing aspects of English life today which would otherwise be utterly ignored in the academies and commercial malls.

Yet the point remains: if you hope to win through on the quality of your ideas, you better have something special to say. An artist who uses pencil and paint skilfully can survive by selling work that does not rise to the highest level, but which is attractive. If a conceptual artist fails, he or she fails absolutely. Much conceptual art is cold and dead not because of the implements the artist is using to convey ideas, but because of the barrenness of the concepts in the first place.

EVERYDAY LIFE
Some towels and a shell in my bathroom. No ideas were involved in the making of this image: I was simply stuck in bed after a knee operation and it was all I could see.

THE SHATTERED URINAL SHOWERS US ALL

13 SOME DRAWING IS ART. SOME ART IS DRAWING. THIS IS A WONDERFUL OPPORTUNITY...

Conceptual art is needed in a book on drawing because the status of drawing fell so far after Duchamp's rewriting of what the word "art" means. Like the aftermath of any explosion, the debris is scattered and awkwardly shaped. Some great traditional artists hang on to their status, like well-decorated rooms exposed to the outside world when half the house has been blown away. Far from the commercial centres of the art world, many thousands of traditional painters and draughtsmen quietly keep going, as if nothing has happened, rather like the late Romans carrying on with their quietly satisfying provincial lives – planting vines, mending tracks – even after Attila's hordes had sacked the Forum.

ISABEL AND EMILY DRYING THEMSELVES
Is this art? No idea, but for me it is the memory of a happy day with my girls Isabel and Emily on a beach. A mere photograph would not bring it back to me nearly as well.

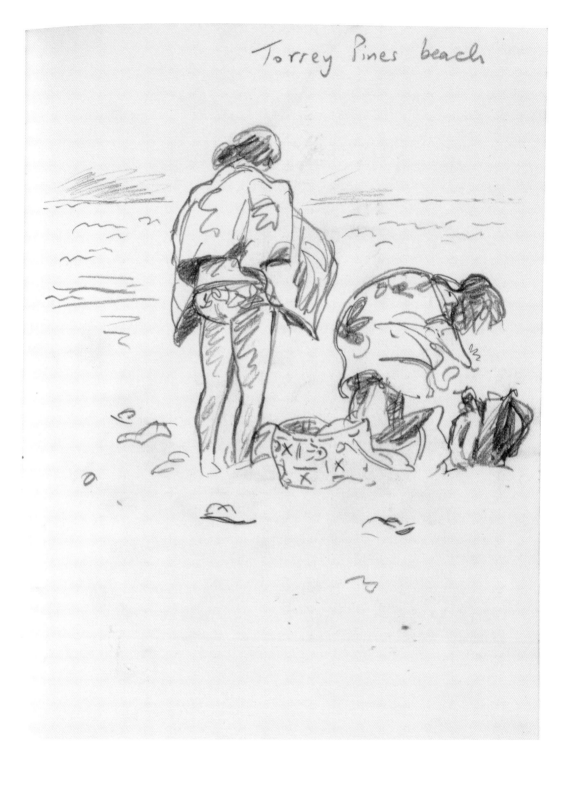

Torrey Pines beach

Yet drawing as a taught discipline is declining. By the early 1960s art colleges became places for ideas, rebellion and experiment, and the stern, correcting teachers were no longer wanted. A long tradition almost ended. In the Courtauld collection there is a drawing by the French artist Charles-Joseph Natoire, made in 1745, of the life class at the French Royal Academy. Two naked men are posing and all round them are students, sketching. The youngest, mere boys, crouch at the floor on the front and the most senior stand at sturdy easels. In the foreground someone, probably Natoire, is talking to and correcting a teenager's drawing. The room in the Louvre is very grand and partly imaginary, but the scene is essentially the same as you would see in any art school during the first half of the twentieth century.

Then it all changed. The careful techniques which were taught in classes from the 1700s to the mid-1900s – the life drawing, the drawing from casts, the cross-hatching and mixing of colours – have mostly fallen away. In the age of computer graphics and concept art, many asked – who needs all that?

David Hockney is the most famous of the artists who lament what happened. He recently told the art writer Martin Gayford that "one of the saddest things ever was the abandonment of drawing in art schools. Even if in the end everyone is self-taught, you can still teach quite a bit in drawing. You can't teach someone to draw like Rembrandt, but you can

teach them to draw quite competently. Teaching someone to draw is teaching them to look."

Yet drawing stubbornly persists. The commercial art galleries are full of well-drawn images. The drawn or painted work of the great twentieth-century masters attracts hundreds of thousands of people to shows every year, many of whom go away and try to draw themselves. The most loved British representational artists, such as Hockney, Lucian Freud and Peter Blake, are or were expert draughtsmen; abstract painters such as Gillian Ayres or Barbara Hepworth are too. Wherever a drawing appears on a TV screen or a newspaper page, as when court artists are allowed to sketch a defendant but photographs are not permitted, the page comes more alive.

There are drawings for adverts, graffiti drawings, drawings on book covers, drawings on park railings, cartoonists' drawings and drawings on (I guess) the walls of most homes, one way or another. Thousands of art clubs and thousands of life classes flourish throughout Europe. Russians trained in old-fashioned Western techniques under communism find their dexterity (while it may be glib and derivative) very popular in the decadent West.

Hockney himself has supplied one theory, which is that the age of photography – the chemical and digital fixing of lens images – is itself only a blip. Even now that cameras are ubiquitous, on most mobile phones and digital pads, we have not arrived in a post-drawing age. Photography is as selective, in

overleaf
HEDGE AND FIELD IN DEVON
I'm not talented enough to make abstract pictures – mine are simply messes – but in this chalk sketch, I fancy myself that you can glimpse how abstract painting emerges, slouching, to be born out of mundane representational sketching.

Jan 3 '07.

fact more selective, than drawing. Its mechanical eye includes a single perspective line only. That is a radical narrowing, a cutting down.

Real seeing is about the watcher as much as the watched. The camera cuts out much of the reality of the living, reacting observer. It's as if life was an endless succession of little windows onto the world, rather than having the world all about us and in us. Now we have easy digital manipulation – a kind of drawing, after all – you cannot even say the camera possesses any unique or useful truth. The flatness and the dullness of much camerawork leaves, therefore, the real work of drawing almost untouched. Hockney goes as far as to say that the age of photography is now coming to an end, that its shallowness is boring us.

He may be ahead of the mass, but it's certainly true that there is something about the physicality and simplicity of drawing that makes it undefeatable. With strips of charcoal or pens, basic tools in our hands, it has barely moved forward. An iPad app which I use all the time, Brushes, is not essentially different. It is faster, brighter, more flexible, but in the end it is a stylus and a surface, and the drawing is just drawing. Personal, direct, drawing has not "advanced". It stands outside glib ideas of progress. And it can remind us of something we are sometimes in danger of forgetting.

AN AWESOME MOSQUE
The largest mud-built building in the world is at Djenné in poor, fanaticism-ravaged Mali. I have photographs of this mosque as well, but they don't get anywhere near the hot and dusty scale of the thing.

SOME DRAWING IS ART

14 THE IMPORTANCE OF MAKING

We have been sold a version of the good life, which is essentially that to live is to consume. To live well means to devour. It means earning enough money to buy new clothes every other month, to eat in restaurants and take home pre-prepared meals, to drive new cars, to have the latest smartphone, stored to the gunnels with music, videos, games and pictures. At a slightly more rarified level, this version of the good life is about devouring new experiences, holidays and even cultural highlights.

Gobbling down life can be rather wonderful but there are obvious drawbacks. For one thing, it cannot go on forever. Indeed, looking at Western indebtedness, water and mineral shortages and the fast-rising population, we may suspect that the jig is

TERRIBLE MAN, TERRIBLE SCULPTURE
This monstrous sculpture of Genghis Khan broods over miles of steppe in Mongolia. It was built from steel by the Chinese for a local politician and is the best case in the world I know for bigger than not being better than. Simply scaling up a second-rate or clumsy image makes it worse, not better.

already up. What are politicians going to say when they can't tell us any longer we will be richer if we vote for them? Meanwhile, we don't seem terribly happy just to be waddling about, endlessly ingesting. That phrase "the dignity of labour" may be musty but it means something.

To make is to have a sense of yourself, a personal dignity which you can't get from consuming – think of all those vacuous celebrity clothes horses with their dead eyes. Of course, there is making and there is making. Making means less (perhaps nothing at all) if you are a cog on a factory line, or a much-abused voice in a call centre providing a "service". Yet to produce – that is, to change the world around us, with our hands and our brains – is the essence of what humans do. To listen to music is relaxing, or exciting. To be able to make it is to be more alive. We all know this. That's why when people have spare time so many get to work in the garden, or go the trouble of cooking their own food.

Drawing is making, like making music, or planting seeds, or chopping herbs and kneading dough. To draw is to produce something which however small, however amateurish, never existed in the world before you made it. In the twentieth century the need for artists to express new concepts may have seemed more urgent. In this century things have moved on, perhaps: I mentioned Matthew Crawford and his motorcycle repair shop earlier. Today, the need to return to making, the urge to express ourselves directly, is coming back with full force.

Sushi at
last
Feb 8 '07

14 04 08
Puntas Arenas
Chile

15 THE FUTURE
OF DRAWING

The Royal College of Art, Kensington Gore, late October 2012. Len Massey is the drawing tutor, and he leads me up a series of narrow staircases to the drawing studio, a surprisingly small attic-like area which, however, has good light. Only around a dozen students can be easily accommodated at any one time, and at first sight it's just what you would expect from the drawing school at a prestigious, ancient institution. A dishevelled platoon of large wooden easels stands in a row. There are plastic skeletons, tangles of wood and works on paper tacked to walls. Len Massey has a small cubicle-like office in the centre of the studio, and a single student, flashily dressed in black tunic and boots, is working late.

A SLEEPING DAUGHTER, AUGUST 2006
Nobody seems very willing to sit for me. Why, I wonder, is that? My daughter Emily, fast asleep, had no choice!

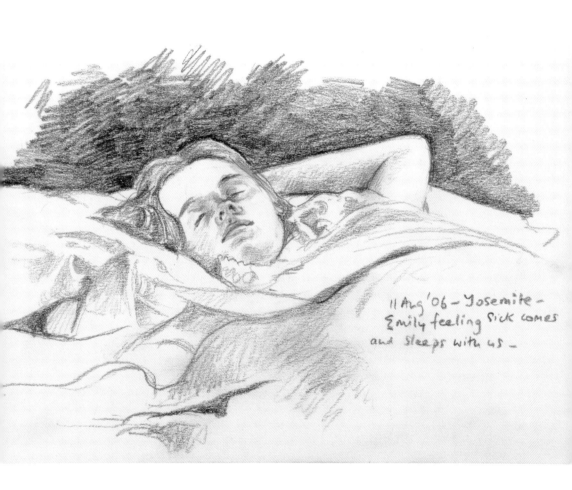

11 Aug '06 – Yosemite –
Emily feeling sick comes
and sleeps with us –

Yet nothing here is what it seems. It is all just a little more interesting. Massey himself, a tall, lean, bearded man in his fifties, with a certain gleam in his eye and a sardonic smile, is a one-time rock and roller. The drawing taught here certainly includes traditional studies – life drawing from nudes, anatomical drawing, the drawing of natural forms. But it stretches away in unexpected directions. Students draw music, with their eyes covered. They draw while running and dancing, round in circles. (Massey calls it "Plato's wallpaper".) They draw on the ceiling. They go to the beach and draw on the sand. They draw with their mouths.

My instinctive reaction would once have been hostile. Massey draws in musicians, including some jazz legends, and has multimedia events. He has encouraged the students to draw straight onto 5mm film stock – the old stuff we used to use in television – and then project the results. He repeatedly tells me he wants students to laugh and have fun here. Among the tutors he has brought in is the alternative comic artist from Brighton, the scabrous Dr Simpo. There are classes in body decoration. Is this really the future of drawing?

Well, it is one of the futures. Some of the twenty to thirty students who come through this MA course each year will go on to be artists in the "fine art" sense. Some are from art colleges but have never been taught drawing there. Others are from engineering backgrounds. Some are becoming textile designers, or doing courses in communication

or animation or vehicle design. "We are a service industry for the whole college," Massey says. People come to further their skills or to escape some of the stress caused by the financial and job pressures around them. Drawing "gives your mind a bit of space to catch up, and to start flowing in… It's nothing to do with meditation. It's something else. It's interesting and it's different."

This echoes what Antony Gormley says about drawing as a zone of freedom. "If you go with it, you can arrive at a place you haven't been before." It may sound a bit mystical, he says, but the act of drawing, "becomes the threshold for you to be the drawing… It's revelatory, not descriptive."

Gormley taught drawing himself and used techniques not unlike those being used at the Royal College. He showed me pages of drawings by students who had had a finger gently moved in a circular pattern from the top of their bodies to the feet, and were told to draw the feeling. Others were the result of students being told to draw simply the sensation of being in their bodies – not the body itself, but the feeling of being in that body.

Massey specialises in bringing in teachers "who are really talented but also really good people, good communicators, good-hearted people." They include, for anatomy, Eleanor Crook, who specializes in forensic reconstruction, and has worked with the police and plastic surgeons as well as fine art students. She in turn was taught by Richard Neave, the British pioneer in forensic facial

overleaf left
SHADOW
Drawing becomes alive again when it isn't entirely familiar. This is a second drawing from the RA's "Bronze" exhibition but this time of shadows on the wall.

overleaf right
LIMBERING UP
Wash and pencil – trying to capture fast-moving swimmers at a gala in Sheffield.

reconstructions. Another is John Norris-Wood, the artist and environmentalist now in his eighties, who teaches natural history illustration and ecological studies.

Massey himself draws with electricity, using a high-voltage source, a big electrode and a chargeable sheet – the same principle as a humble photocopier, but pushed much further. It can be slightly dangerous, he admits. He was taught in Wales by, among others, Roy Ascott who, after working on RAF Fighter Command radar systems, went on to become a pioneer in cybernetic and interactive computer art. Massey rarely shows his pictures. They are extraordinarily beautiful, showing for instance the electric emanations from his fingers – the electrical exchanges around us all the time that we rarely notice.

So there is today a radical re-exploration of what drawing means, using very traditional tools such as graphite pencils and poster paints, but also projectors and computers. Everything I saw was clearly drawing. But it was mostly unfamiliar, though some went right back to the first comic-book drawings I enjoyed as a child. Drawing is bigger than we think.

Second, much of it addressed my earlier, unanswered question: what is drawing *about*? (And in particular, what should it be about now?) There's a lot of politics in this. The Royal College drawing room was also the room where A.A. Gill brought a group of others to draw, for his celebration of the

nude and the life class. But Antony Gormley had an interesting criticism of the practice. Indeed, he finds it "slightly offensive" and an attempt to render a human being like a landscape. As a student, he vividly recalled the room with a radiator, a mattress, a girl being roasted on one side and chilled by a draught on the other as she stayed still for 45 minutes. What was this, he asked, but conquest, the hunter and the hunted?

Gormley cited specifically the art of Lucian Freud ("bless his soul"), so many of whose models are viewed from above, lying abject below the artist's "analytic gaze in which his desire to make the image is much stronger than their reality as willing, feeling, thinking, human beings." Pablo Picasso's art dealt obsessively with the same subject, "the artist's need to eat his model… there's a lot of the hunter in it." So for Gormley the subject of art remains a huge one – "is art another way of capturing things and expressing one's power over them?" Good drawing, by contrast, is about penetrating the surface of things to explore what's happening inside, and inside the artist. Gormley, famously, has responded to this problem by making his own body his obsessive life-long subject.

These are the questions which will shape the future of drawing, along with new materials to draw with. Drawing needs to be connected to the big problems of life – and of life today. We live in a world which is environmentally fragile and humanly frantic. Drawing needs to be *about* that. This is not

a call for didactic or political drawing. Nor is it in any way a rejection of beauty. Just the opposite. But the great religions, the political hierarchies and the old ideologies all expressed themselves through drawing. So to ask what drawings are of today, is only to take drawing seriously – to give it its due.

Finally, there is the art and market problem. The Royal College's drawing school is not a place which seems obviously corrupted by big money. It might have a grand title but it isn't wealthy. It isn't much bigger than a three-bedroom flat. Massey does not regularly exhibit his work at galleries. "I don't like the contemporary art market," he says. "It's about novelty and celebrity and vacuousness and money. I am not interested." So he makes the work for himself and his friends, and helps students escape becoming mimicries of celebrity artists, and has fun.

And this may be the most liberating thing of all – freeing drawing and painting from selling, investing, hoarding and all the pressures and corruption that goes with it. If I was younger and sillier I'd start all over again and hope to get to a place like the Royal College, not to have a career but to be a more interesting – that is, a more interested – human being.

ON THE YACHT 'PHILOS' GOING UP THE DARWIN CHANNEL
In the end, my pictures are my unsaleable "artobiography". Like this, they are more about feeling and the memory of feeling then anything else. But feeling needs to be put into shape, and that's why we all draw.

overleaf
OUT OF THE NIGHT
Travelling with the Queen: this red carpet was rolled out at an Arab airport, waiting in the darkness for hours until she arrived. I've just stuck it in because it makes me laugh.

THE FUTURE OF DRAWING

The feeling of being on the yacht "Philos" going up
the Darwin channel, Thu. Oct 19th, with Ben + Skye, en
route back to Porto Williams. A cold wind but hot sun.

→ Eventually, we head back to the Darwin channel itself after a day of
perfect filming weather, to do a final PTC as the sunset falls - great orange
bars of light, Wagnerian peaks + huge menacing clouds. We've done all the
filming we actually need, tho' the final PTC isn't quite right - tomorrow is
all bonus. Skye cooks a decent roast beef meal, we eat + drink copiously -
Next hez brought a bottle of Lagavulin - + then we turn in to tiny bunks while
Ben - I think of him as Earth to her Skye - takes us to our next mooring.